IMAGES
of America

EL SOBRANTE

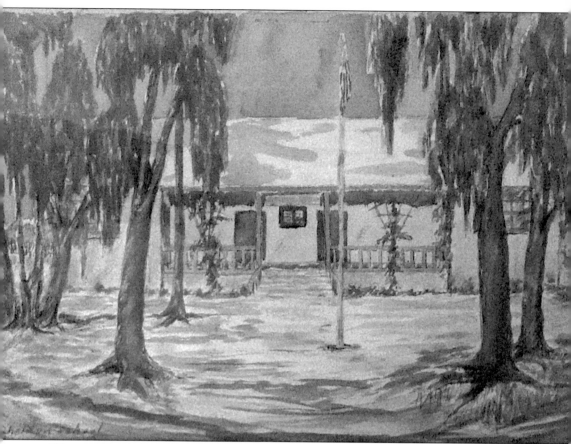

WATERCOLOR, SHELDON SCHOOL, 1949. The artist is Frances Martin, who taught first through third grade when the school was expanded to two rooms during World War II. For 72 years, from 1880 to 1952, local children attended grammar school at this site along Castro Road, currently the site of the Sherwood Forest Freewill Baptist Church. (Courtesy of Donald Skow.)

ON THE COVER: EL SOBRANTE VOLUNTEER FIRE DEPARTMENT, 1949. In July 1949, El Sobrante crossed a major milestone with the dedication of a modern station equipped with the latest firefighting equipment. The town was growing rapidly, and the new housing developments called for a higher level of sophistication in firefighting techniques. The men in this photograph are, from left to right, (standing) Leo Logan, Ray Vogel, Carl Kistler (from the State Fire Marshall's Office), Russell Brusie, George Lehmkuhl, and Ralph Wadge; (kneeling) Willard Heide, Joe Mansfield, Stanley Skow, Ed Kamb, Lester Skow, Ed Campbell, Robert Hayden, Virgil Philippi, Sparky Sanders, and R. Vogel Jr. (Courtesy of Edward Campbell.)

IMAGES
of America

EL SOBRANTE

Donald Bastin

ARCADIA
PUBLISHING

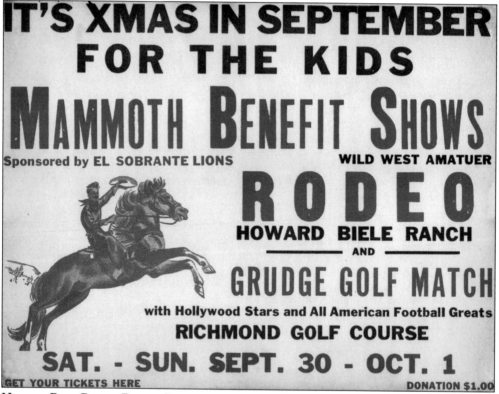

HOWARD BIELE RANCH RODEO, SEPTEMBER 1950. Rodeos have always been a part of El Sobrante. The Biele Ranch was located at the present site of the Olinda Elementary School; for decades, it was a popular spot for equestrian events. The purpose of this event was to raise money for a children's recreational area, and was sponsored by the Lions Club. The event was attended by Don Red Barry, a popular western star of the time. A king, Bob Patterson, and queen, Tiny Banducci, were selected to preside over the festival. (Courtesy of Bob and Marilyn Patterson.)

CONTENTS

ACKNOWLEDGMENTS

Aside from the images gleaned from the collection of the Contra Costa County Historical Society and a few other organizations, all of the photographs in this book were obtained directly from the private collections of local residents. The number of people who were contacted and who graciously offered to share their memories is too large to list, but some contributors must be acknowledged. In alphabetical order, I wish to thank Maurice Abraham, the Adachi family, Doraleen Andrade, Frank Banducci, Laverne Banducci, Pastor Gaye Benson, Steve Benson, Evelyn Botti, Fred Brown, Deanna Faria Brownlee, Pastor Deborah Butler, Anne Cain and the Contra Costa Library, Kenyon Chan, Contra Costa County Fire Protection District Station 69, the Contra Costa County Historical Society, Jim Cowen, Betty DeGrace, Ed Greene, the El Sobrante Library, Steven James, Harold Huffman, Robert Jeha, Ron Kamb, the Keil family, John Koepke, Richard Langs, Robert Letford, Bob Louis, Eleanor Loynd, Penny McMenomy, Brenda Montano and the East Bay Regional Park District, Alberta Nunes, Bill Oliver, Tom Panas, Bob Patterson, the Pedracci family, Don Peterson, Dorothy Philippi, Andrea Pook and the East Bay Municipal Utility District, Margaret Faria Prather, Vincent and Laura Romano, Ed Rossman, Paula Banducci Sanchez, the Sherwood Forest Freewill Baptist Church, Donald and David Skow, and Vesper Wheat. In particular, I wish to thank Richard Oliver and Edward Campbell for their extraordinary assistance and access to their extensive photograph collections. Lastly, and far from least, I wish to acknowledge the help of my wife, Clementina Diaz, whose enthusiasm and sound judgment were a constant source of inspiration.

To those who may have been left off this list inadvertently, please accept my apologies and my sincerest thanks for your help.

INTRODUCTION

What is El Sobrante? It is not an easy question to answer. Unincorporated, it is technically defined as a census-designated place (CDP) within Contra Costa County. In its heart lies a large chunk of territory falling within the city limits of Richmond. In fact, the Richmond boundary lines, resulting from over 50 years of piecemeal annexation, has led to a legally and politically fractured community; however, strangely enough, the community retains a great deal of social integrity. Thus, the residents of the Richmond area of El Sobrante, more often than not, view their legal status as a technicality and hold proudly to their real status as El Sobrante residents. The El Sobrante Chamber of Commerce apparently supports this concept. In 1998, they produced a street map of their community, showing the El Sobrante area as "comprised of areas which are unincorporated, shown in white, and areas which have been annexed by Richmond, shown in blue." Additionally, the postal zip code for the El Sobrante area, which is 94803, includes the Richmond segment. As much as anything else, the US Postal Service has succeeded in defining the community of El Sobrante.

Determining the population of El Sobrante is also a challenge. As of the 2000 census, the population of the CDP was pegged at just over 12,000. But this does not include the areas of Richmond surrounded by the boundaries of the CDP, which would probably double the above figure. Therefore, the overall population of the community is probably around 25,000 individuals—neither large nor small.

Geographically, El Sobrante lies between the towns of Richmond and Pinole, with Orinda to the east. At its eastern boundary is the San Pablo Dam, holding back the waters of San Pablo Creek. The creek still runs year-round from the reservoir to the bay, neatly bisecting El Sobrante. For thousands of years, local Indian groups lived along San Pablo Creek, taking advantage of the yearly salmon runs and the animal and plant life that thrived along this riparian corridor. The ranches of the Californios and the later European settlers also naturally grew up along this ribbon of life. Though we take little from it now, the creek still provides a habitat for wildlife and peace for the weary human mind.

In 1821, Mexico won its independence from Spain and inherited the province of Alta California. In order to secure its tenuous hold on the area, large tracts of land were granted to ex-soldiers and government officials. In 1823, Don Francisco Castro made application for the 18,000-acre Rancho San Pablo. Other grants followed in rapid succession, but it was not unusual for *sobrante* (surplus) land to remain unclaimed. Thus, in 1841, brothers Juan Jose Castro and Victor Castro (sons of don Francisco) applied to Governor Alvarado for the sobrante land lying between the Ranchos San Antonio, San Pablo, Pinole, Valencia, and Moraga. The request was granted, but the issue was complicated by the fact that the surrounding ranchos had indefinite boundaries, which led to years of legal contention. While Victor's claim to Rancho El Sobrante was confirmed in 1882 (Juan Jose died in 1869), most of the acreage had been sold off to pay for legal fees. By 1893, only 549 acres remained

By the mid-19th century, the El Sobrante Rancho was already being divided into relatively small plots of up to around 500 acres. These newcomers, many having emigrated from Europe, naturally settled along San Pablo Creek, or one of its tributaries, for much the same reasons as the Native Americans. By the 1890s, county maps showed much of the land in the possession of the families of Abrott, Warnecke, Amend, O'Neill, Thode, and others. The era of large ranchos had evolved into the age of smaller ranches, where cattle and horses roamed, and crops of many kinds were produced. But the evolving community attracted no heavy industry. Unlike many of the other towns that grew up in Contra Costa County, El Sobrante would never be a company town. Because of this, and unlike its company town neighbors, its historical trajectory was never clearly defined.

The rural phase of El Sobrante's history lasted until the mid-20th century. The major development of the early 20th century was the construction of the San Pablo Reservoir, which disrupted development of the ranches located along the stretch of San Pablo Creek that was flooded by the dam. The population grew very little, and even by 1937 the number of residents was estimated to be only around 100. It was the coming of the World War II that drew people to El Sobrante, as it did to the rest of California and the Bay Area. By 1950, the population had ballooned to 7,000 and was confidently predicted to go much higher. The 1950s were a boom period for El Sobrante, and for the first time serious consideration was given to the possibility of incorporation. Strangely enough, the idea of incorporation has never caught on among the general population. Repeated efforts by the chamber of commerce, the local weekly newspaper, and other civic groups have consistently failed to generate much enthusiasm for incorporation (or, alternatively, annexation to neighboring Richmond or Pinole). But perhaps the lack of any large business base made the idea of becoming a city impractical in the long run. In any case, "We like El Sobrante as it is" seems to be the town's motto.

El Sobrante has managed to hold on to its rural roots, where ranches still exist, where horses are raised and ridden, and where cattle roundups are still part of the rhythm of life. It is this story, the struggle to maintain its historic open land and natural beauty against the encroachment of development that has shaped the community of El Sobrante.

One

LEFTOVER LAND
FROM PREHISTORY TO 1915

For thousands of years, Native Americans made their homes in the area we now call El Sobrante. It is clear from the archeology of the area that San Pablo Creek was a favorite stopping place. In the right season, it yielded abundant quantities of fish and provided clean fresh water, as well as a respite from the summer sun. The coming of Spanish settlers in the late 1770s brought this innocent age to an end. The avalanche of Americans brought by the lure of gold in the mid-19th century completed the destruction of a vital Native American presence in California. Along the San Pablo Creek, only curious mounds remained to tell the story of vanished people.

Members of the Castro family, who were also holders of Rancho San Pablo, were granted Rancho El Sobrante in 1841. Following the Gold Rush of 1849 and the granting of California statehood in 1850, the Castros, like most other Californio families, saw their land slip through their fingers. The era of the ranchos was giving way to the era of the ranches.

In the late 1800s, the community of El Sobrante did not exist. Though a few schools served the children of the ranching families, there was little else to define a community. The area where the town would grow was popularly known by a few stops along a little narrow-gauge train line that ran from Emeryville to Orinda, following San Pablo Creek. Oak Grove and Laurel Glen were popular places to have a picnic, hike the hills, or have a party. To the weary urbanites of the city of Oakland, these areas were places that offered peace and quiet, and the beauty of a natural rural landscape. In many ways, this rural beauty is still drawing people to El Sobrante.

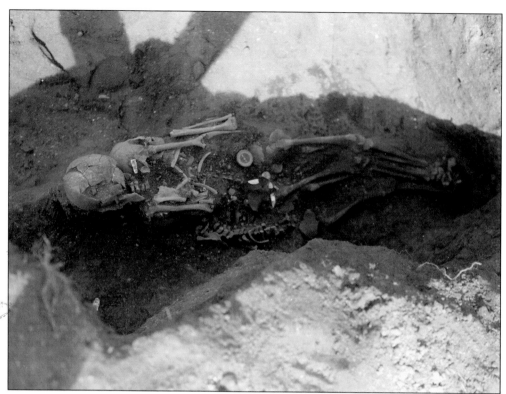

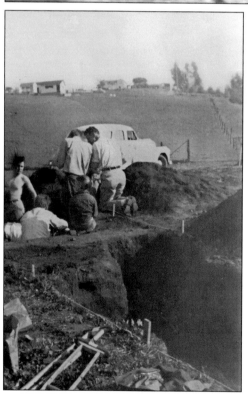

NATIVE AMERICAN BURIAL SITE, SAN PABLO CREEK, 1950. Evidence suggests that Native Americans have lived along San Pablo Creek for thousands of years. In 1950, a team of researchers from UC Berkeley, under the direction of Prof. Robert Heizer, unearthed 11 bodies on the property of Virgil and Dorothy Philippi. The lower photograph shows UC students at work digging a trench. The Philippi family owned three acres of land, stretching from Santa Rita Road down to the banks of San Pablo Creek. The Indian mound was located near the creek, and Professor Heizer estimated that the people had lived there 2,000 to 3,000 years ago. The bodies were stretched at full length, as in the above image, rather than in the usual fetal position—an interesting cultural variation, according to Professor Heizer. (Courtesy of Dorothy Philippi.)

HUNTING PARTY, C. 1870. The desperados in this photograph are, from left to right, Harry Bridges, unidentified, Willie Barker, and Patricio Castro. Patricio was born in 1843 and moved to his 100-acre ranch in El Sobrante in 1868. This photograph may have been taken on his ranch. This is the earliest image we have of Patricio, son of Victor Castro. (Courtesy of Contra Costa County Historical Society.)

CASTRO FAMILY, CASTRO RANCH, EARLY 1900S. In 1841, Victor and Juan Jose Castro petitioned for leftover land lying between existing grants. Though the grant was confirmed in 1882, only a few hundred acres were left by that time. Patricio Castro has the stick in his hand, and his son Percy is on the horse. (Courtesy of CCCHS.)

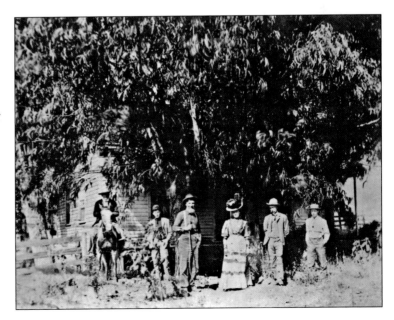

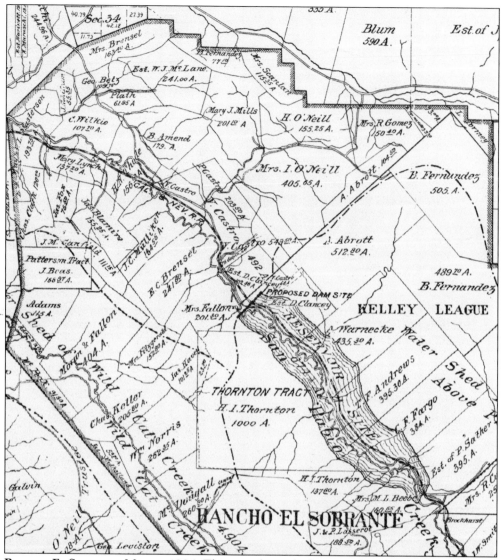

RANCHO EL SOBRANTE MAP, c. 1894. This map shows the large ranches that were created from the remnants of the old Castro land grant. Running through the center of the map is San Pablo Creek, and beside the creek was the C&N rail line. Under each name is a number denoting the acreage of the parcel. Some of the names are familiar to local residents. Burkard Amend has a road named after him, as does Charles Clark. Charles Wilkie had a farm along a little tributary of San Pablo Creek, to which his name is now attached. A reminder of the presence of the Castro family is Castro Ranch Road, running about two miles from San Pablo Dam Road to the intersection with Pinole Valley and Alhambra Valley Roads. Castro Creek, a tributary of San Pablo Creek, runs along the road. Note that as of this early date, a reservoir was already planned along the San Pablo Creek watershed. (Courtesy of CCCHS.)

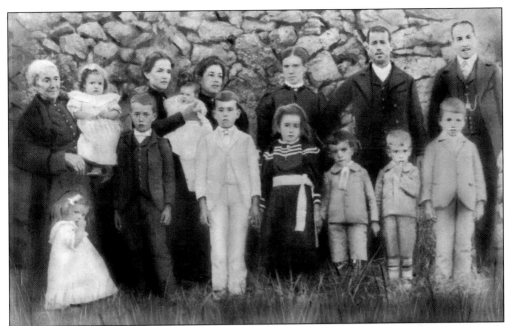

NUNES FAMILY, AZORES, C. 1908. Jacinto Nunes arrived in California in 1907, leaving his family in the Azores. By 1914, he had set up ranching on the Abrott property in El Sobrante and sent for his wife and children. Pictured here from left to right in the first row are Mary, Joseph, Frank, Irma, Antone, Jess, and unidentified. Jacinto's wife, Maria, is the second woman from the left in the second row, holding little Serene. Jacinto's mother, on the far left, is holding little Lucy. The other adults are not identified. (Courtesy of Laverne Nunes Banducci.)

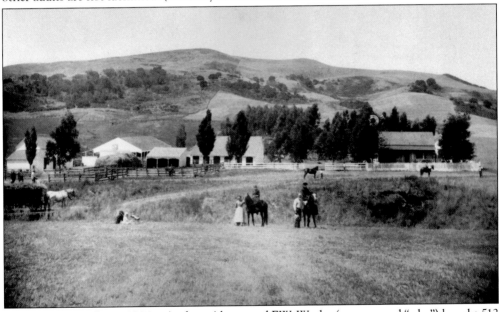

ABROTT RANCH, LATE 1800s. Andrew Abrott and F.W. Weyhe (pronounced "why") bought 512 acres of land in the hills above San Pablo Creek in 1859. Both men built homes and went into ranching. Later, son Fred Abrott leased land to the Newell and the Nunes families. Cattle ranching is still carried on by descendants of the Nunes family. (Courtesy of CCCHS.)

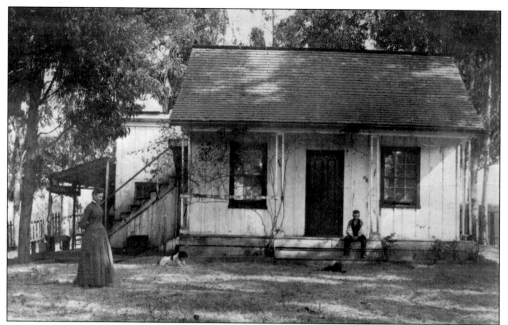

BEEBE RANCH, 1892. The Beebe Ranch, consisting of 160 acres, was located at the far eastern end of what is now the San Pablo Reservoir. Pictured are Mrs. Beebe, the former Mrs. Jerry Norman, and her son Robert. (Courtesy of CCCHS.)

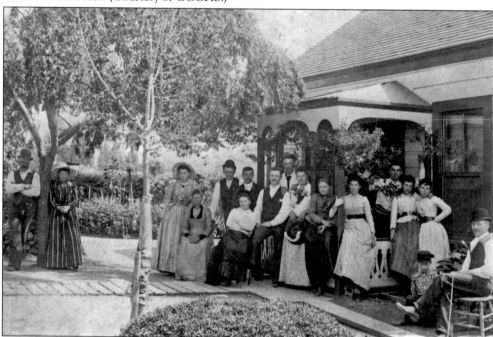

THODE RANCH, 1880s. H. Nicholas Thode immigrated to San Francisco from Germany in 1869. He moved to Contra Costa County 18 months later and built this home in 1880, on what is now Valley View Road, just north of the present intersection at Olinda Road. The house, one of the oldest in El Sobrante, still stands. Nicholas and his wife, Elsabe, are probably the couple standing by the tree. (Courtesy of CCCHS.)

TOM MALONEY AND WIFE, LATE 1800s. Tom Maloney owned a large ranch along what is now Appian Way, which stretched all the way through present-day Pinole to San Pablo Avenue. Until 1953, much of what is now Appian Way was known as Maloney Road, in Tom's honor. The original farmhouse, much altered, is still standing, just to the north of the post office. (Courtesy of the Pedracci family.)

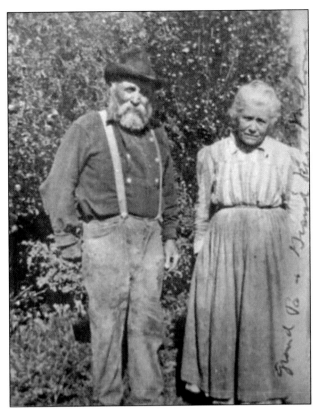

WARNECKE RANCH, MAY 25, 1890. August Warnecke immigrated to America in 1849, and moved to California in 1854. He purchased 435 acres along San Pablo Creek in 1881. He later leased the home to a Danish immigrant, Soren Skow, who began a dairy operation on the property. (Courtesy of CCCHS.)

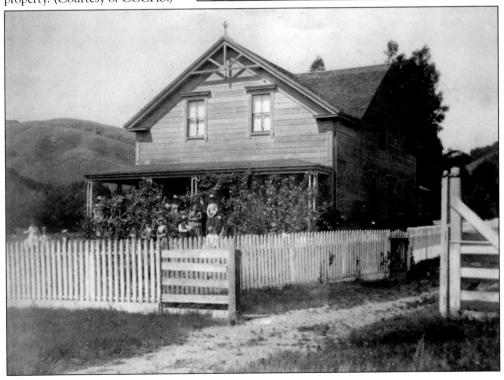

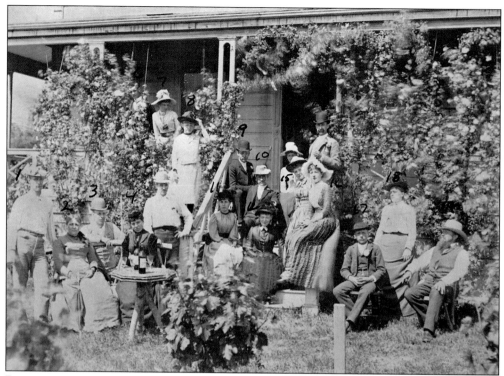

PARTY AT WARNECKE RANCH, MAY 25, 1890. Pictured and numbered in this photograph are Edward Warnecke (1), Sophia Warnecke (2), John Koster (3), Olivia Castro (4), John Plath (5), Richard Harms (6), Emma Folkers (7), Lotta Warnecke (8), August H. Warnecke, son (9), George Huested (10), Meta Koster (11), Augusta Duisenberg (12), Adele Folkers (13), Orson Huested (14), Clara Holling (15), Dora Warnecke (16), Walter Warnecke (17), Mrs. Fred Koster (18), and August Warnecke (19). (Courtesy of CCCHS.)

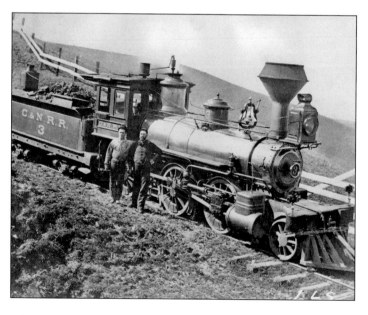

CALIFORNIA AND NEVADA RAILROAD, TEWKSBURY HILL, C. 1894. The little C&N Railroad Company was incorporated in 1881, with grand plans to run from Emeryville to Nevada; however, it never got beyond Orinda. Three engines were originally planned, but only two, No. 1 and No. 3, were built. The engineer (right) is H. Aleck Robertson, standing by his fireman, George Pope. (Courtesy of Ed Rossman.)

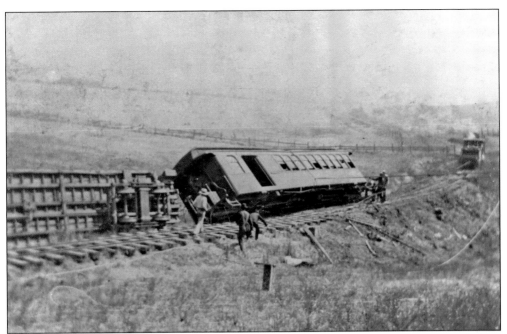

TRAIN DERAILMENT, AUGUST 3, 1885. This C&N passenger car left the tracks on the Tewksbury grade, just before entering the El Sobrante Valley. Derailing was not uncommon, given the instability of the local soil, particularly on the slopes. However, the train crews were prepared for such occurrences, and, with help from the male passengers, the cars were often moving again within a short time. (Courtesy of CCCHS.)

OAK GROVE, C. 1885. Thought to have been located at the current intersection of Dam and May Roads, the more probable site is further east at the area that became La Honda Bowl. In 1887, this was as far as the C&N Railroad had progressed. H. Nicholas Thode owned the site's land and provided picnic tables, a dance floor, and food for hungry travelers. (Courtesy of CCCHS.)

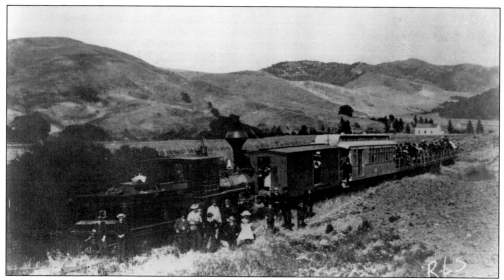

CALIFORNIA AND NEVADA EXCURSION TRAIN, 1888. One boxcar, a passenger car, and three flatcars are shown stopped just beyond Oak Grove and just short of Sheldon School in the distance. The happy excursionists are on the way to the planned town site of Olinda, where the Olinda Elementary School is today and at that time, where the end of the line was located. (Courtesy of CCCHS).

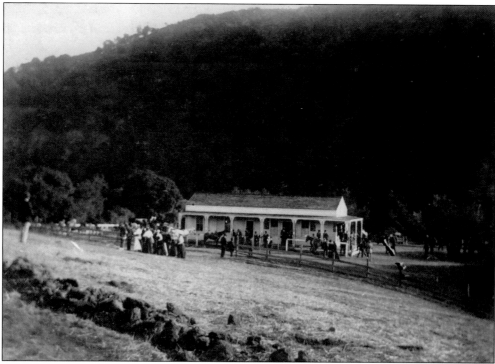

CHURCH SOCIAL, LAUREL GLEN RESORT, 1899. By 1889, the train was running to Laurel Glen, a resort located on the property of Daniel Clancy, an Irish immigrant, which included the present-day Kennedy Grove. Most of the picnic sites in Kennedy Grove are named for stops along the C&N train line. (Courtesy of CCCHS.)

LAUREL GLEN, EARLY 1900s. When the C&N Railroad stopped running in 1900, the only way to get to the popular picnic sites along San Pablo Creek was by wagon, horseback, or later by automobile. This photograph was probably taken around 1905, judging by the large floral hats worn by the ladies. (Courtesy of CCCHS.)

SAN PABLO CREEK, EL SOBRANTE AREA, LATE 1800s. This picture was probably taken somewhere near Oak Grove, or perhaps on San Pablo Creek near the old Sheldon School. It reinforces the notion of the importance of the creek as a place of recreation. (Courtesy of Ed Rossman.)

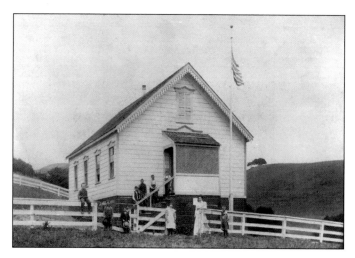

MOUNT PLEASANT SCHOOL, 1902. The Mount Pleasant School was founded in 1869, and served the children of the ranch families along San Pablo Creek. It was located toward the eastern end of the present-day reservoir, and the site is now underwater. The teacher was Anastasia Dean, and James Chester Brockhurst is identified as the 14-year-old boy at the top of the stairs. (Courtesy of CCCHS.)

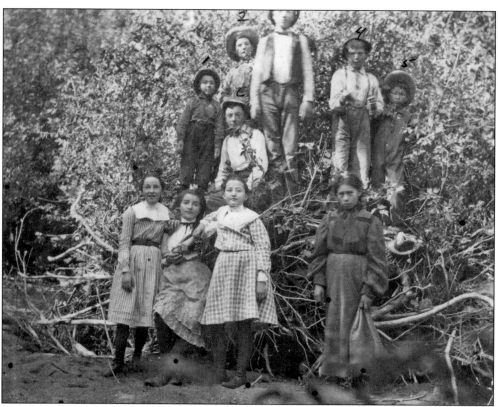

CLASS AT SHELDON SCHOOL, C. 1898. Pictured and numbered from left to right are George Lehmkuhl (1), Percy Castro (2), Billie Lehmkuhl (3) Charles Quinting (4), Al Marcella (5), and Willie O'Neill (6). The four girls at the bottom are, from left to right, Lucy O'Neill, Victoria Castro, Annie O'Neill, and Rosie Marcella. (Courtesy of CCCHS.)

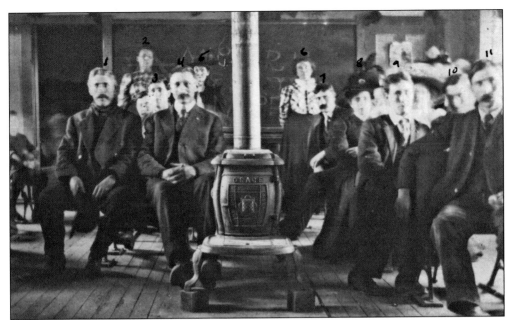

SCHOOL TRUSTEES MEETING, SHELDON SCHOOL, C. 1905. The Sheldon School was founded in 1880, with help from local landowners Martha Sheldon and Burkard Amend. Pictured from left to right are Mr. Avilla (1), Anna Skow (2), unidentified (3), Soren Skow (4), two unidentified people, John Lazzerot (7), Rose Cunningham (8), Olaf Owen (9), unidentified (10), and Joe Lazzerot (11). (Courtesy of CCCHS.)

CASTRO FAMILY, PERCY CASTRO RANCH, C. 1915. Pictured from left to right are Herb Brennan (1), Patricio Castro (2), Victoria Castro Brennan (3), Percy Castro (4), Harriet Fitzgerald Wahlender (5), Edy O'Neill Blume (6), T.J. Fitzgerald (7), Jovita Fitzgerald (8), Jovita Castro Fitzgerald (9), and Rose Cunningham Castro, Percy Castro's wife (10). (Courtesy of CCCHS.)

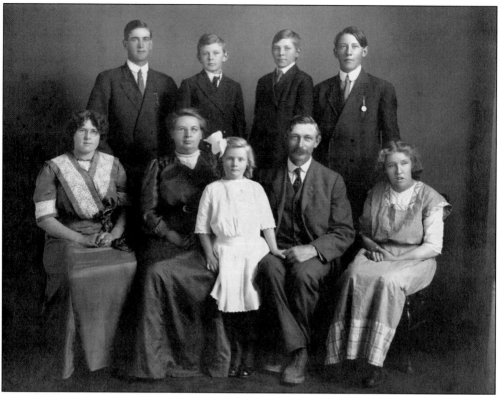

SKOW FAMILY, 1912. Soren Skow and Anna Rasmussen were immigrants from Denmark. Around 1899, Soren started his dairy business, renting property from the Warnecke family. Pictured from left to right are (first row) Eda, Anna, Erma, Soren, and Ethyl; (second row) Harold, Ellis, Lester, and Wilbur. Anna had a fondness for girls' names beginning with "E." (Courtesy of the Richard Skow family collection.)

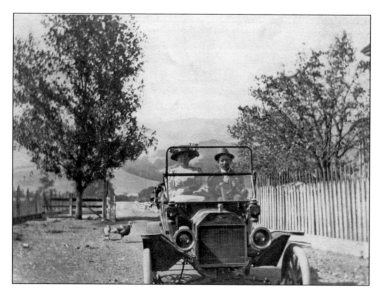

SOREN AND ANNA SKOW, 1915. Here, we see Soren and Anna in their 1913 Model T Ford, next to the old Warnecke home. With construction of the San Pablo Reservoir, the Skows were obliged to move. In 1921, they relocated to a site along Clark Road, where they maintained their business until 1955. (Courtesy of the Oliver Family.)

Two

THE BEST LITTLE TOWN BY A DAM SITE
1916 TO 1940

With the beginning of construction of the San Pablo Reservoir in 1916, we enter a new phase in the development of the community of El Sobrante. With the reservoir came a reliable source of water, availability of electricity, and paved roads. Some of the ranchers along the new reservoir continued to operate in a leaseback arrangement with the water company, but others resettled elsewhere. Soren Skow, who had begun his dairy operation on land leased from the Warnecke family in 1899, moved to a new location along Clark Road, near present-day downtown El Sobrante.

Ranch houses below the waterline of the new lake were torn down. Other buildings were abandoned and fell into disrepair. Today, only the Nunes Ranch, on property that was once part of the Fernandez and Abrott parcels, remains as a viable ranching operation. The land has always been leased. Now, it is leased from EBMUD.

During the 1930s, as the nation struggled with the greatest financial meltdown in its history, the San Pablo Reservoir was the site of wholesome activity, as boys from the Civilian Conservation Corps came to build roads, plant trees, chop down the thick stands of eucalyptus, and build rock walls and dams. This work constituted an extension of the general change in the landscape that came with water company ownership of the land. The reservoir not only changed the natural flow of San Pablo Creek; it has forever altered the area around it, and it is still changing today.

Despite its name, the San Pablo Reservoir has always been a part of, and associated with, the community of El Sobrante. From the earliest days of its construction, it has forcefully defined the community and has been seen as its greatest amenity, especially since its opening to the public. The reservoir and its operator, EBMUD, have a close and enduring relationship.

PATRICIO CASTRO, CASTRO RANCH, c. 1916. In 1916, work began on the San Pablo Dam. Patricio Castro and his son Percy were able to profit from this huge construction project by supplying the beef and pork consumed by the construction workers. The ranch continued to sell fresh beef until the 1980s, under the direction of Percy's son Percy Jr. (Courtesy of CCCHS.)

DAM FACE CONSTRUCTION, 1917. The wooden trestle structures are flumes, designed to carry dirt washed down from the hillsides. This slurry was the fill for the dam face and is no longer an accepted practice. The People's Water Company was incorporated in 1906 and began to buy up land for dam construction. Unable to meet demands, it was taken over by the East Bay Water Company in 1916. (Courtesy of EBMUD.)

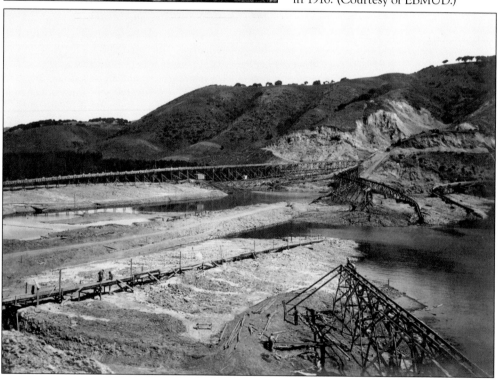

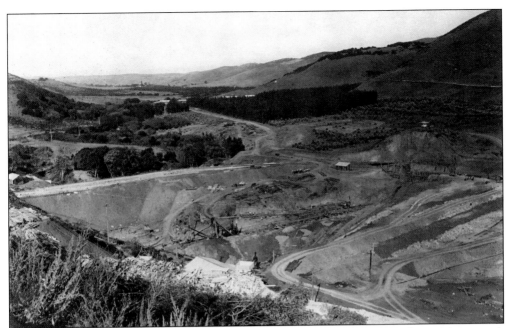

GENERAL VIEW OF MAIN DAM, DECEMBER 6, 1917. This primarily westward view shows work progressing on the inside of the dam face. Beyond the dam is the El Sobrante Valley, with the trees in the center defining San Pablo Creek. At the right are the Eucalyptus trees that still dominate Kennedy Grove, with a patch of young trees that may have been planted by the People's Water Company. (Courtesy of EBMUD.)

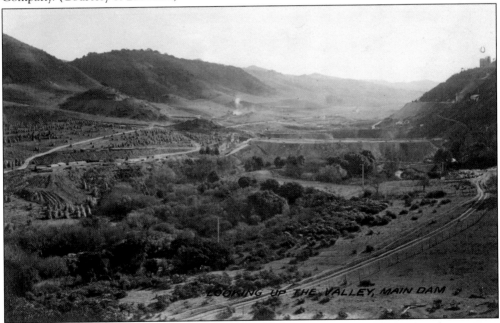

LOOKING EAST, JANUARY 7, 1918. This photograph, taken just one month after the previous shot, shows the dam from the opposite direction. On the left is another trestle that brought down slurry from the hillsides. Piles of lumber are stacked and ready for use in building more structures as needed. (Courtesy of EBMUD.)

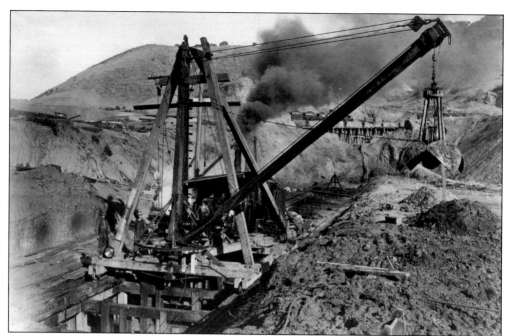

ORANGE PEEL RIG, DECEMBER 15, 1917. The orange peel rig was a variation of the clamshell device, with four segments instead of two. Though the dam was completed by 1921, the East Bay Water Company was fumbling. In 1923, Contra Costa and Alameda County residents voted to create the East Bay Municipal Utility District, which still operates the reservoir. (Courtesy of EBMUD.)

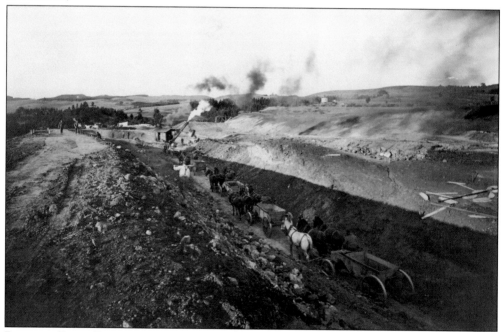

BUILDING FILTER PLANTS, OCTOBER 30, 1919. By this date, the dam face had been completed. This view is generally east, at the eastern end of the reservoir. A steam shovel is shown at work, but horses were still heavily relied upon. (Courtesy of EBMUD.)

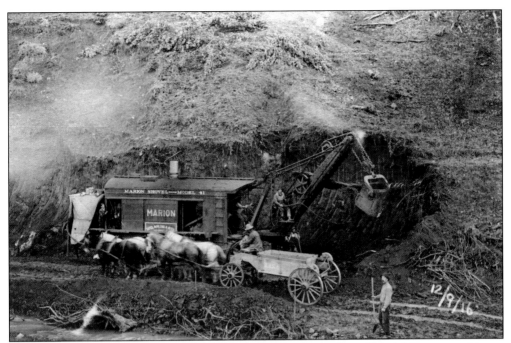

STRIPPING CREEK BANK, DECEMBER 9, 1916. The Marion Steam Shovel Model 41 was a workhorse at the San Pablo Dam site. Its shovel could scoop 1.5 yards of dirt at a time. San Pablo Creek is visible just at the lower left of this image. (Courtesy of EBMUD.)

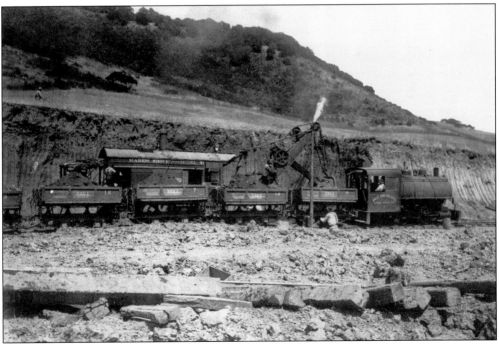

MARION 41 LOADING CARS, JUNE 17, 1917. Here, the steam shovel is at work again, this time filling train cars with rubble and dirt. The train was operated by general contractor Bates, Borland, and Ayer, out of Oakland. (Courtesy of EBMUD.)

27

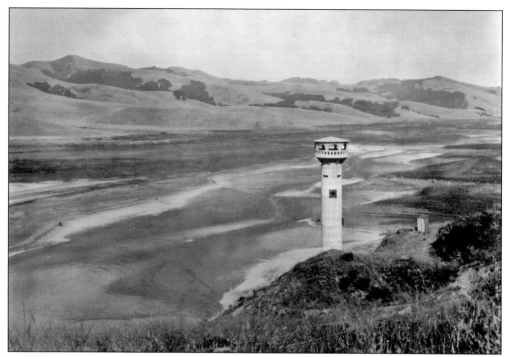

FIRST WATER FROM MOKELUMNE RIVER, 1929. In 1918, little water had flowed in San Pablo Creek for two years due to a drought. It was clear that another source of water was needed. In 1923, the East Bay Municipal Utility District was formed and immediately began construction of an aqueduct from the Mokelumne River. Water began to flow in July, but the dam was not full until 1936. (Courtesy of EBMUD.)

JACINTO AND MARIA NUNES, ABROTT RANCH, 1921. Jacinto Nunes emigrated from the Azores in 1907 and settled on the Abrott ranch in 1914. With his wife and family, he raised dairy cattle and hay. The family always rented the property. Today, Alberta Nunes rents from the current owner, the East Bay Municipal Utility District. (Courtesy of the Nunes family.)

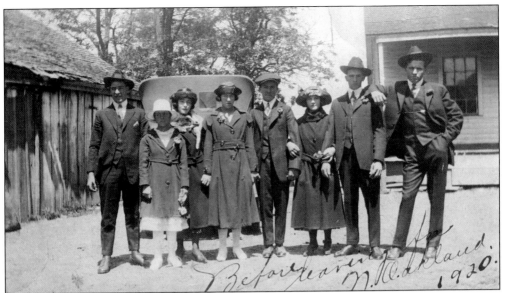

NUNES FAMILY, WEYHE RANCH, 1920. In 1859, Andrew Abrott and F.W. Weyhe purchased land in the hills above San Pablo Creek and constructed homes at separate sites on the property. The Nunes family lived, at one time or another, at both sites. The family is pictured just before leaving for a trip to Oakland. They are, from left to right, Antonio, Serene, Erma, Lucy, Antone, Mary, Jess, and Frank. (Courtesy of the Nunes family.)

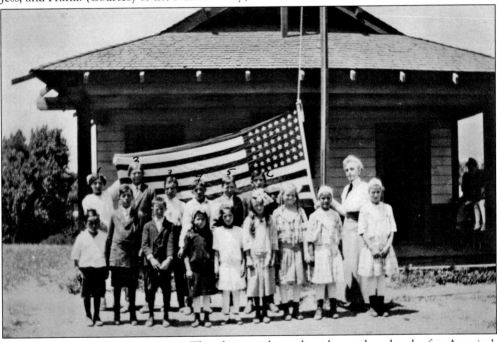

CLASS AT SHELDON SCHOOL, C. 1917. This photograph may have been taken shortly after America's entry into World War I in April 1917. The teacher is Miss Cody. The students are, from left to right, (first row) unidentified, Joe Nunes, Alfred Abdale, unidentified, Serena Nunes, ? Abdale, Erma Skow, Mary Nunes, and Lucy Nunes; (second row) Ida Nunes (1), Ellis Skow (2), Antone Nunes (3), Joe Alameda (4), Leland Abbott (5), and Jess Nunes (6). (Courtesy of CCCHS.)

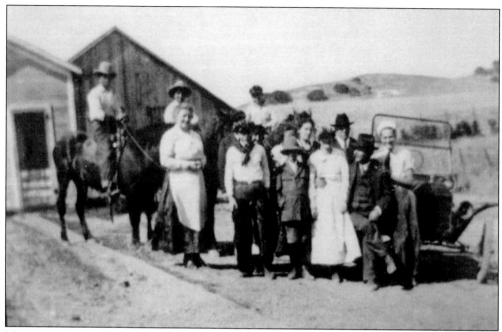

MALONEY FAMILY PICTURE, MALONEY RANCH, C. 1916. This picture looks northwest, with Appian Way, previously Maloney Road, just beyond the fence visible above the Model T Ford's windshield. The little building at the left is still standing on the property and is used as a storage shed. The barn has been torn down and replaced by a more modern structure. (Courtesy of the Pedracci family.)

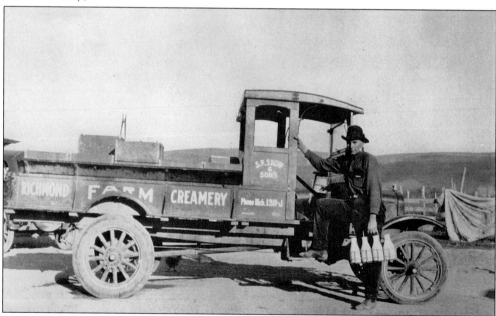

LESTER SKOW, SKOW DAIRY, C. 1921. Soren Pedersen Skow had four sons, Harold, Ellis, Lester and Wilbur. Here, we see Lester standing by one of the Model T Ford dairy trucks. According to Lester's son Donald, the dairy was called the Richmond Farm Creamery because Richmond was their primary market for most of the time that the company existed. (Courtesy of CCCHS.)

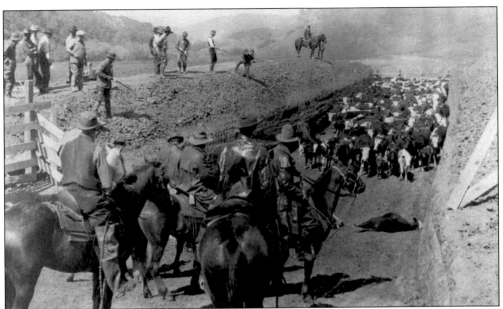

HOOF-AND-MOUTH OUTBREAK. In 1924, a deadly outbreak of the hoof-and-mouth disease in Contra Costa County necessitated the destruction of whole herds of cattle, including all of the dairy cattle on the Skow Ranch in El Sobrante. The cattle were herded into a pit and shot. According to an account in *A History of Contra Costa County, with Biographical Sketches of the Leading Men and Women of the County Who Have Been Identified with Its Growth and Development from the Early Days to the Present*, published by Historic Record Company in 1926, the Skows lost "367 head of good stock." It took years to recover from this blow. (Courtesy of CCCHS.)

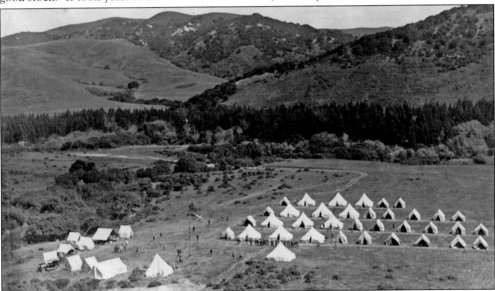

RICHMOND HIGH SCHOOL MILITARY ENCAMPMENT, APRIL 24, 1921. Each year, high school senior boys would participate in a five-day campout engaging in drill, shooting competitions, and a general introduction to military life. The site of this encampment has been uncertain. However, investigative research done by resident historian Steve Benson has revealed that the actual site is the present-day Canyon Oaks subdivision. This photograph looks north. (Courtesy of CCCHS.)

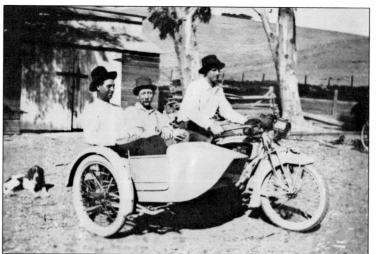

MOTORCYCLE WITH SIDECAR, C. 1922. Not much is known about this image, except that the man in the middle is Soren Skow, who seems to be enjoying himself, and that the photograph was taken somewhere along San Pablo Dam Road. The other two men are unidentified. (Courtesy of Ed Rossman.)

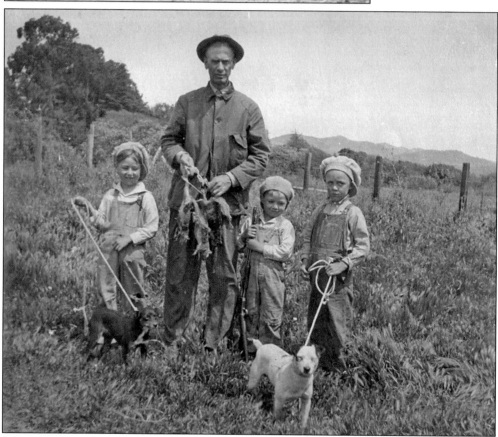

SQUIRREL HUNTING, SKOW DAIRY, C. 1926. The name of the man holding the squirrels is not known, but he may have been a hunting buddy of Harold Skow. To his right is Dugan Skow, and to his left is Raymond Skow. The boy holding the white dog is Melvin Lehmkuhl. By this time, the dairy was located along Clark Road. Squirrel hunting was fun for the boys and eliminated an annoying pest, as the burrows sometimes caused cattle to break legs. The squirrels were also eaten. (Courtesy of the Oliver family.)

SMALL GAME HUNTING, SKOW RANCH, C. 1926. On the left is Dugan Skow. His brother, Raymond, is holding the .22 caliber pump-action rifle. On the right is Melvin Lehmkuhl, the only son of George Lehmkuhl. (Courtesy of the Oliver family.)

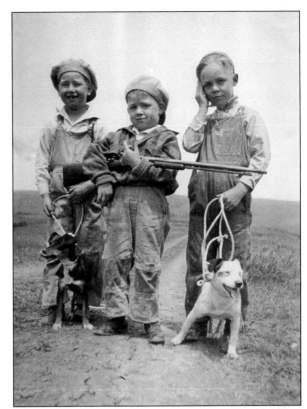

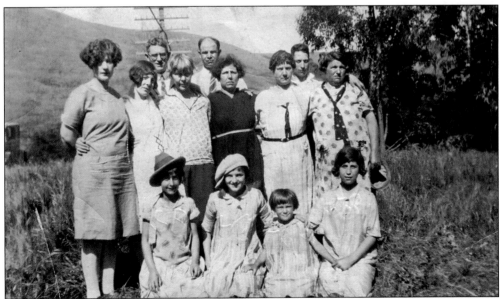

MIKULICH FAMILY, 1928. Josef Mikulich (third row, second from left) immigrated to the United States from Croatia in 1909. In 1928, he homesteaded 10 acres along San Pablo Creek, where he operated a chicken ranch. His daughter Mildred, second from the right in front, married Richard Keil. In 1942, they built a home along Hillside Drive on part of Josef's property. The couple spent the rest of their lives in this home, which is still standing. (Courtesy of the Keil family.)

33

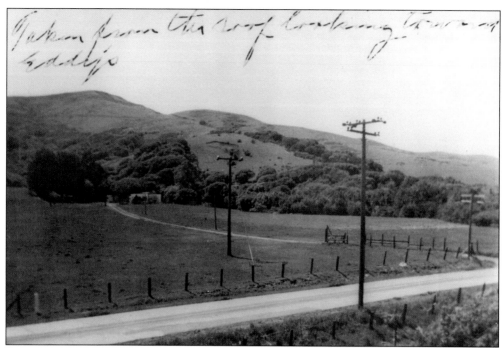

SAN PABLO DAM ROAD, C. 1930. This photograph was taken from a rooftop and is looking west or southwest toward San Pablo Ridge. The driveway and home are located roughly in the area along the current Oak Creek Road. The note on the photograph says, "Taken from the roof looking toward Eddy's." The identity of Eddy is unknown. (Courtesy of Ed Rossman.)

DAIRY TRUCKS AND DRIVERS, 1933. Though it was called the Richmond Farm Creamery, the Skow Dairy was never located in Richmond. George Lehmkuhl married Eda Skow, the daughter of Soren and Anna, and Melvin was his son. Ellis and Lester were sons of Soren and Anna, the founders of the business. Stanley was the son of Harold (Harry), the oldest son of the founding family. Pictured from left to right are George Lehmkuhl, Ellis Skow, Stanley Skow, Lester Skow, and Ed Kamb. (Courtesy of the Oliver family.)

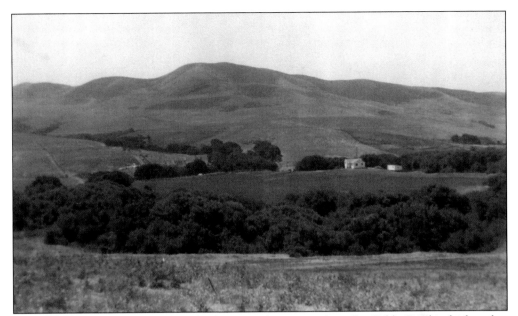

CAMPBELL HOME SITE, C. 1935. In the foreground are trees along San Pablo Creek, which makes a big loop at this point, just before it enters downtown El Sobrante at Appian Way. Locals referred to this site as "the island." Just beyond the trees, across the island, is the Campbell home. This area is now the site of the popular Canyon Pool. (Courtesy of Edward Campbell.)

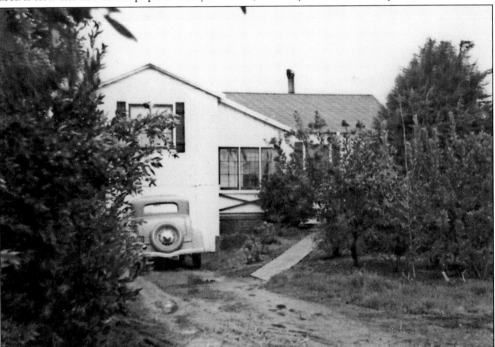

CAMPBELL HOME, C. 1935. Walter and Alice Campbell moved from Rodeo to El Sobrante in 1934, building a home just off of Dam Road, on a short road that became Campbell Lane. Across San Pablo Dam Road was the sprawling Skow Dairy, where the young Ed Campbell worked from time to time, and where he met his future wife, Jean. (Courtesy of Edward Campbell.)

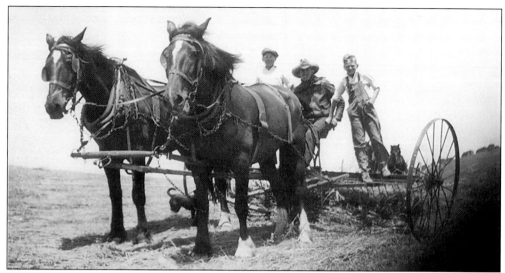

TWO-HORSE HAY RAKE, SKOW DAIRY, MID-1930S. The dairy grew some of the feed hay for its stock, but much had to be purchased. Here, we see Dugan Skow (left) and Melvin Lehmkuhl. The driver could be Dick Anderson, an all-round cowboy and ranch hand. First the hay was mowed, then raked, and then baled. The hay press was owned by an individual who went from farm to farm at harvest time. (Courtesy of the Oliver family.)

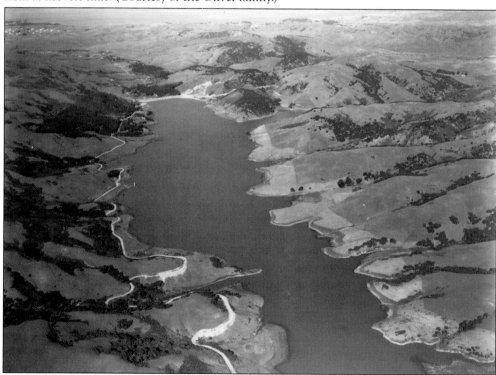

AERIAL, SAN PABLO RESERVOIR, 1935. This view looks west toward the face of the dam. The white line following the lake contours is the old San Pablo Dam Road, which many old-time residents remember as a sickness-inducing drive. A new, straighter highway was built in the 1950s, and the old road has since served EBMUD as a service road. (Courtesy of EBRPD.)

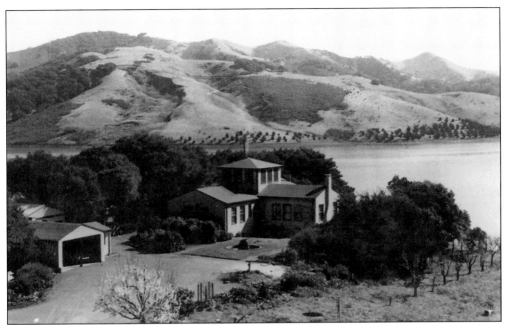

RESERVOIR SUPERINTENDENT HOME, LATE 1930s. This house was built next to the reservoir for Superintendent Ogden. It was a handsome structure and was surrounded by fruit trees. Unfortunately, it was determined that the house was too close to the reservoir to ensure proper sanitation, and it was torn down in the 1940s. (Courtesy of Edward Campbell.)

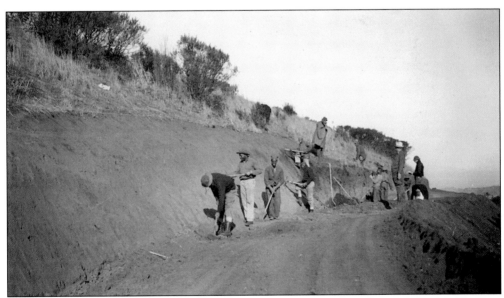

CIVILIAN CONSERVATION CORPS, SAN PABLO RESERVOIR, NOVEMBER 1935. From at least January 1934 and for several years thereafter, the CCC worked around the San Pablo Reservoir, building roads, clearing and planting trees, and constructing rock check dams. This is an African American group (the CCC was segregated) building a fire trail. (Courtesy of EBRPD.)

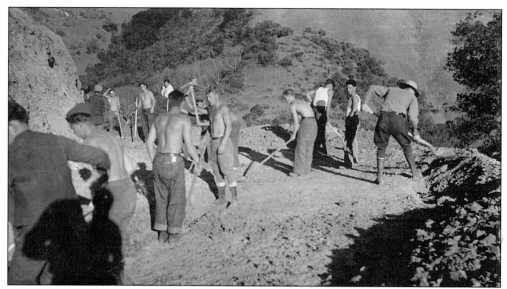

ROAD CONSTRUCTION, CCC, SAN PABLO RESERVOIR, C. 1935. These lads from the Civilian Conservation Corps are building a fire road along the north-easterly side of San Pablo Reservoir. The CCC provided healthy, outdoor work for young men, and they were paid $30 a month. All but $5 went to the boys' families, which was very welcome during the dark days of the Depression. (Courtesy of EBRPD.)

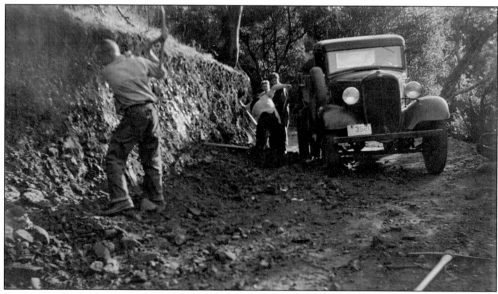

SOBRANTE ROAD CONSTRUCTION, DECEMBER 1934. Sobrante Road is a utility road and fire trail on the northeast side of the reservoir that is still very much in use. Whether it was the hard work or just the times, all of the boys in these images seem to be in good shape. (Courtesy of EBRPD.)

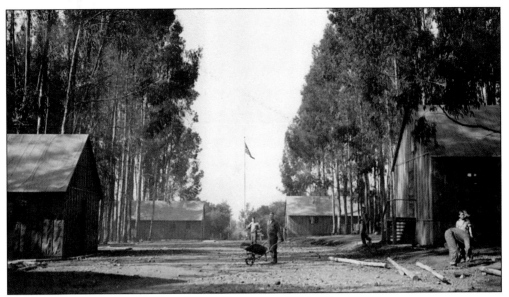

CCC Camp, Kennedy Grove Area, February 1934. The CCC camps were run on a semi-military basis, with emphasis on discipline and order. The camp at the San Pablo Dam was no exception. This view is looking west away from the dam and just west of the camp dispensary. (Courtesy of EBRPD.)

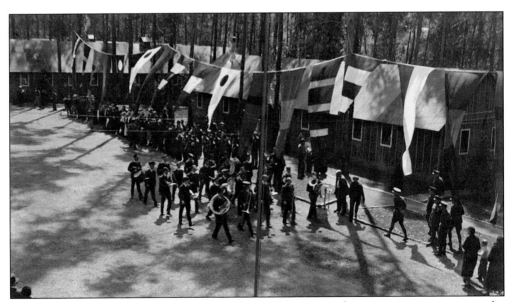

Intercamp Field Day, March 24, 1935. The CCC encouraged sports competition among the various camps. The music was provided by a local high school ROTC marching band. (Courtesy of EBRPD.)

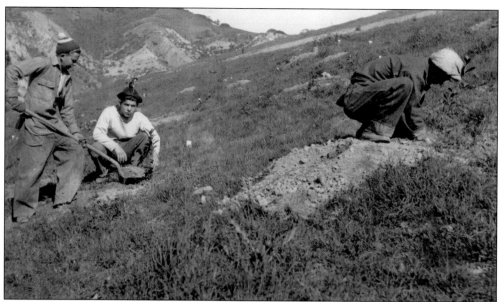

REFORESTATION WORK, FEBRUARY 1935. These CCC boys are planting trees on the slope of the dam face (not a recommended practice these days). According to the information included with the image, they were planting toyons, madrones, blue myrtles, strawberry trees, and cherry trees. (Courtesy of EBRPD.)

REAMES ROAD CONSTRUCTION, JANUARY 1934. This fire trail, located southwest of the dam, was another project of the CCC. Looking down the hill to the left, the old San Pablo Dam Road and San Pablo Creek (indicated by the line of trees) can be seen. Beyond the creek is Hillside Drive. The slide area seen at the middle left is the site of the current Heide Court. (Courtesy of EBRPD.)

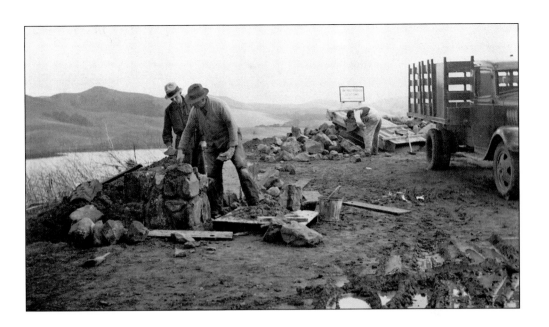

ROCK WALL CONSTRUCTION, MARCH 1935. As part of the work done by the CCC, this rock wall was built along the old San Pablo Dam Road near the outfall tower, creating an observation point. The top photograph shows the beginning of construction, while the bottom photograph shows the completed wall. Beyond the opening in the center was a broad rock stairway that was constructed leading down to the water's edge. This is curious, given that the dam was not officially opened to the public until 1973. The wall and stairway still exist, and is on land that is open to the public. (Courtesy of EBRPD.)

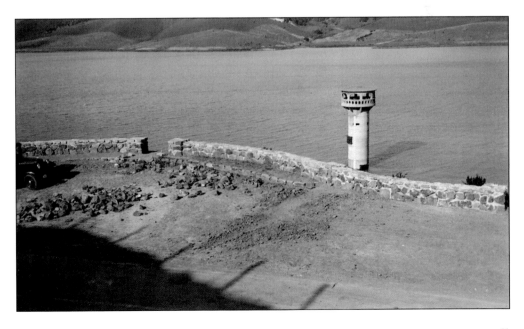

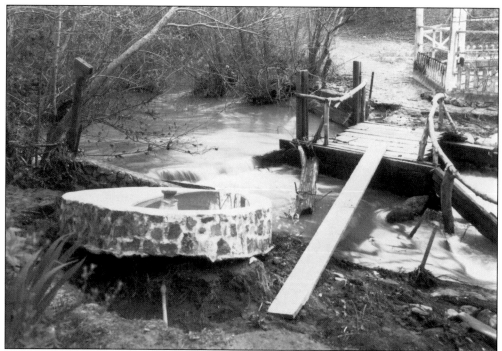

LA HONDA BOWL, FEBRUARY 24, 1936. A popular picnic and recreation area, La Honda Bowl was located along San Pablo Creek between Old Road 19, present-day D'Avila Way, and La Honda Road. The winter of 1935 to 1936 must have been wet, as the little footbridge is partially washed out. The rock structure in the foreground seems to be a displaced fountain. In the background is the corner of a little merry-go-round. (Courtesy of EBMUD.)

SKOW DAIRY TRUCK, LATE 1930s. This disabled truck is parked on May Road at the intersection with Valley View Road. At this time, May Road and Valley View were unpaved. Wilkie Creek, which runs under Valley View at this point, gets its name from Charles Wilkie, who ran a 107-acre ranch here. The men are, from left to right, Ray Skow, Walt Lucksinger, Jim Woods, and Dick Anderson. (Courtesy of Edward Campbell.)

LAVERNE, JESS, AND DORALEEN NUNES, APRIL 13, 1938. These are the children of Jess Nunes, son of Jacinto, who emigrated from the Azores in 1907. The home in the background was part of the old Abrott Ranch, which was destroyed in a fire in 1965. The palm trees are still standing. Laverne later married Ed Banducci Jr., who owned and ran Ed's Tavern. (Courtesy of the Nunes family.)

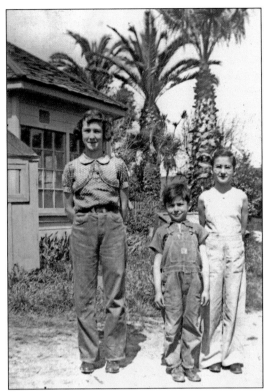

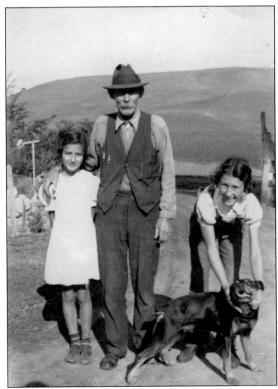

FRED ABROTT WITH NUNES CHILDREN, NOVEMBER 17, 1937. Doraleen Nunes (Andrade) is standing with Fred Abrott, from whom the Nunes family rented their property. Laverne, later Banducci, is the other girl in the photograph. (Courtesy of the Nunes family.)

"Nick," Nunes Ranch, Late 1930s. The Nunes family grew vegetables, in addition to raising cattle. When the crop ripened, Filipino workers, all men, would help with the harvest and be put up at the old Weyhe Ranch house. These men would move from ranch to ranch as needed. Nick was one of these workers. (Courtesy of Laverne Nunes Banducci.)

Rodeo at Castro Ranch, July 1936. This image looks south over land now occupied by Olinda School. This flat area was a favorite spot to hold events with horses. Past the parking area is Castro Road, now Olinda Road, and beyond that is the eucalyptus grove that was cleared in the 1950s to create the Sherwood Forest housing development. (Courtesy of the Nunes family.)

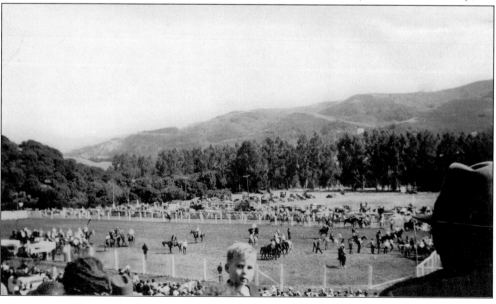

Three

GRASSFIRE GROWTH
THE 1940S

As it was for the rest of the Bay Area, the reason for the population surge in El Sobrante during the 1940s was World War II. People came from all over the country to work in the shipyards, particularly the Kaiser yards that operated in Richmond. Many lived for a time in the crowded housing projects that were quickly thrown up around the yards. But as soon as they could, many moved out. For those people who had grown up on rural farms or in a country environment, the open hills, fields, trees, and running creeks of El Sobrante offered a reminder of home.

As of 1937, El Sobrante's population was estimated to be no more than 100. By 1950, that number had jumped to 7,000. In 1944, in response to a growing need, the county organized the El Sobrante Fire Protection District. It is this district, more than anything else that framed the boundaries of the community from that point forward.

During the war years, new housing developments appeared primarily in the hills off Appian Way. At the same time, individuals were constructing their own homes, with little meddling from the county, in the hills near Sobrante Avenue. Just after the war, new developments, built by Earl "Flat Top" Smith, appeared along San Pablo Dam Road. Businesses took root along the area between Road 20, now El Portal, and Appian Way. In 1943, a gas station and hardware store were built, and by 1949, the town had its own movie theatre. The biggest event was the opening of the new fire station on Appian Way in July 1949. More than anything else, this was a symbol of the growing importance of the community of El Sobrante.

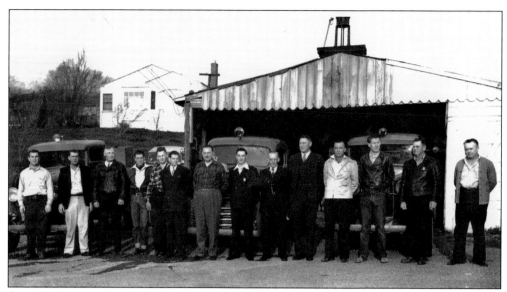

SOBRITO RANCHO FIRE DEPARTMENT, 1942. This station stood on Appian Way, directly across from the present station. The volunteers are, from left to right, Russell Brusie, Charlie Steves, George Lehmkuhl, Albert Valentine, Peter Wick, Ray Vogel, Leo Logan, Charley Matteson (Chief), Al Shepston, Wilbur Skow, S. Saunders, Ed Campbell, Carl Head, and Bob Tolton. (Courtesy of CCCFPD, Station 69.)

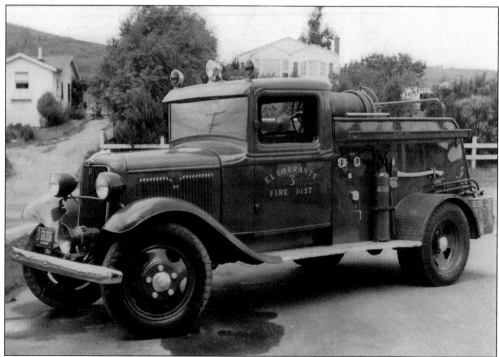

1934 FORD FIRE ENGINE. This Ford fire truck was used for many years in the original "Sobrito Rancho" department, and may have been in use when the department was located on the Skow Dairy property. By the time the new station was built in 1949, it seems to have been out of general service. (Courtesy CCCFPD, Station 69.)

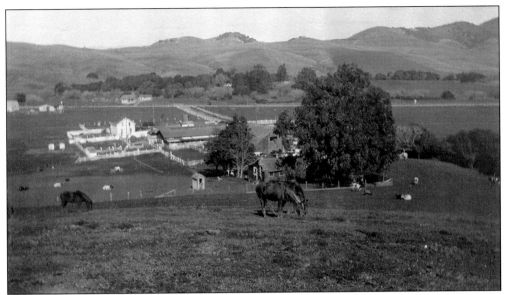

SKOW DAIRY, C. 1942. The Skow Family Dairy (Richmond Farm Creamery) is pictured from the hills past the end of Clark Road. At this time, the dairy dominated the otherwise mostly empty valley and hillsides and, according to a historical account, may have encompassed 900 acres at one time. The home at the far left along San Pablo Dam Road was built in 1929 by Lester Skow and is still standing today. (Courtesy of the Oliver family.)

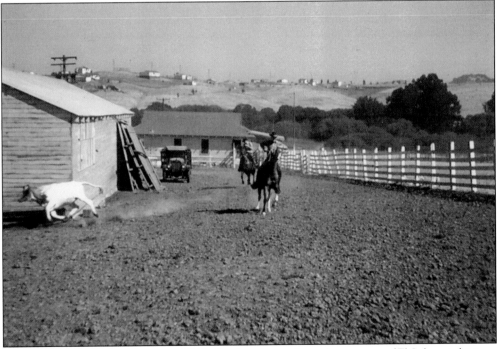

RODEO PRACTICE, SKOW DAIRY, C. 1942. Cowboys have always been a part of El Sobrante history. In this image, two riders are chasing a calf, getting ready for the next rodeo. Behind the riders is the bunkhouse, which had served formerly as the Sheldon School. It was later moved across Clark Road to become Canyon Park Market. (Courtesy of Edward Campbell.)

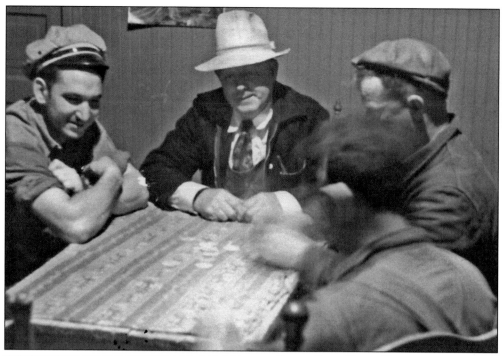

INSIDE SKOW DAIRY BUNKHOUSE, c. 1942. The old Sheldon School house was moved to the Skow property around 1932, and served as a bunkhouse for the Skow Dairy workers. It was the fourth of five Sheldon school buildings. According to Ed Campbell, who occasionally played cards there, it was a "bad-smelling place—nobody ever took a bath." The men pictured are, from left to right, Dugan Skow, Tom Cochrane, and Walt Lucksinger. (Courtesy of Edward Campbell.)

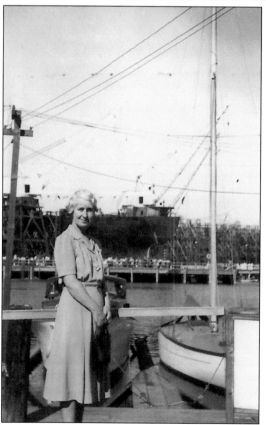

ALICE CAMPBELL, RICHMOND SHIPYARDS, c. 1943. Like many women, Alice Campbell worked in Richmond's shipyards during the World War II. Alice was an accounting clerk, and her son Edward said she was "pretty good at it." Work was a necessity, as her husband, Walter, died in 1941. (Courtesy of Edward Campbell.)

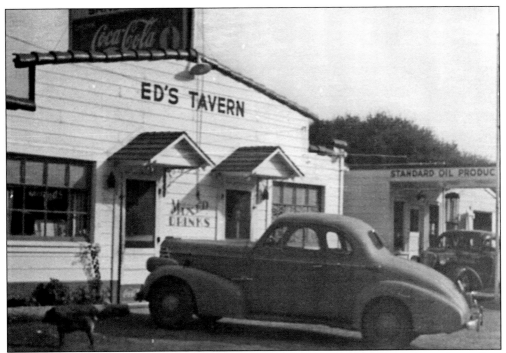

ED'S TAVERN, C. 1940. Ed Campbell's Oldsmobile is parked in front of Ed's Place, located on San Pablo Dam Road near the intersection with Castro Road, now Valley View. This photograph shows the bar as it looked when Ed Banducci Sr. and his wife, Teresa, bought it in the late 1930s. In the 1950s, it was substantially remodeled with a brick facade, and has changed little since. (Courtesy of Edward Campbell.)

INSIDE ED'S TAVERN, WORLD WAR II. During the war, there was a small Army base located within the eucalyptus grove that later became Sherwood Forest. This image shows Ed and Teresa Banducci (center) entertaining some of the boys from that camp. Ed built a large room attached to the bar just for such events. (Courtesy of Laverne Nunes Banducci.)

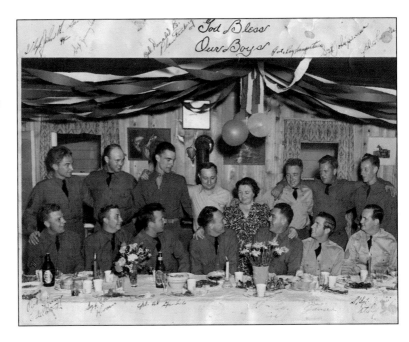

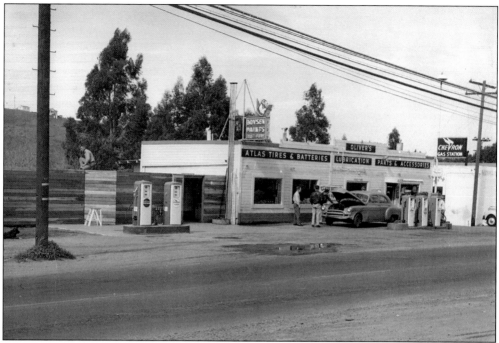

OLIVER'S GAS STATION, C. 1949. John Oliver bought the original hardware store and gas station from Mr. Olafson in October 1943. John did not particularly like running the business and sold it to his son Bill in 1948. This image shows the business much as it looked when it was first purchased. (Courtesy of the Oliver family.)

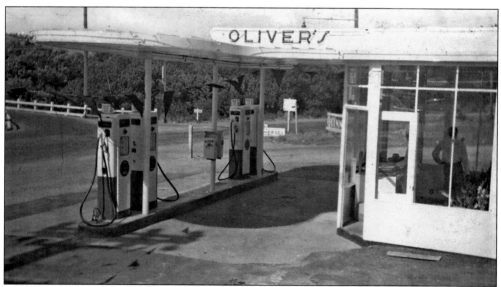

OLIVER'S UNION 76 STATION, AUGUST, 1946. John Oliver had this station built and opened it in 1946, at the corner of San Pablo Dam Road and La Colina Road. Unlike the Chevron station, it was never a success. This view is east, and at the left is the old bridge over San Pablo Creek at Appian Way. (Courtesy of the Oliver family.)

INTERSECTION OF FIELDCREST AND OAK KNOLL ROAD, c. 1947. This photograph looks roughly east. The home at 5727 Oak Knoll is still standing and has barely changed. This area of north El Sobrante, not far from Sobrante Avenue, never was subject to mass development. Today, it consists of homes largely built individually by the original owners. (Courtesy of Steve Benson.)

NORTH EL SOBRANTE, C. 1947. This northwest view was taken from the site of the Benson home at 6050 Oak Knoll Road, which was originally bought in 1946. The prominent road (left, center) is Thompson Lane. Maloney Road, now Appian Way, is at the far left. Many of the homes in this image are still standing. (Courtesy of Steve Benson.)

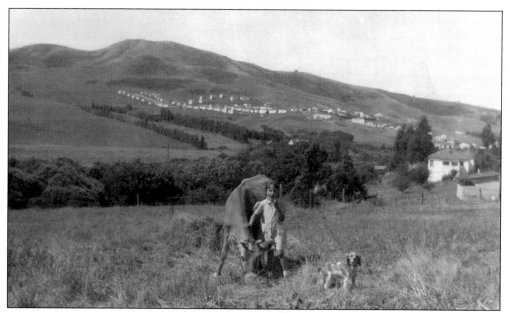

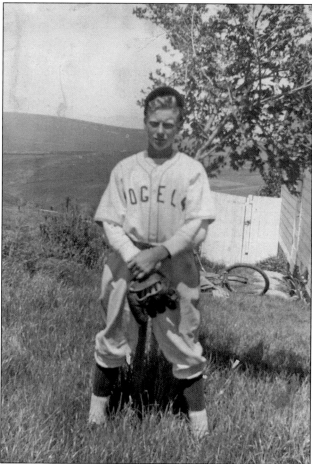

PHILIPPI HOME, C. 1947. Virgil and Dorothy Philippi built a home on Santa Rita Road in 1946, with lumber taken from another house that they bought and tore down. Their land extended down the hill to San Pablo Creek. In this image, daughter Jeanine is standing by the family cow "Beauty" and her dog "Freckles." On the hill in the distance, we can see new housing built along La Colina Road. (Courtesy of Dorothy Philippi.)

BOB PATTERSON, 864 ALLVIEW AVENUE, C. 1947. Bob Patterson and his wife, Marilyn, grew up in El Sobrante and still call it home. The Patterson family moved into their home on Allview Avenue in the 1940s, which was the last home on the street at the time, and is still standing today. Here, we see Bob in his baseball uniform, sponsored by Ray Vogel's store in El Sobrante. (Courtesy of Bob and Marilyn Patterson.)

RICHARD KEIL, DAIRY DRIVER, C. 1948. Richard Keil worked as a delivery driver for the Skow Dairy at one time. This photograph appears to have been taken in Richmond, near some of the wartime housing still in use at that time. (Courtesy of the Keil family.)

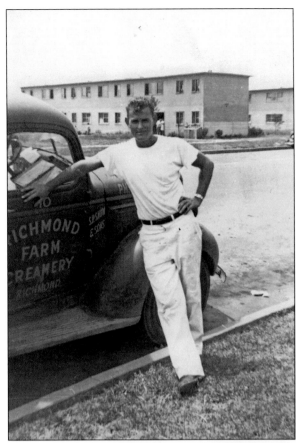

KEIL AND STANLEY CHILDREN, HILLSIDE DRIVE, C. 1948. The two boys are Jim Keil (left) and Richard Stanley. The girls are not individually identified, but belong to both the Keil and Stanley families who lived next door to each other on Hillside Drive, which runs along the top of this photograph, between the fence posts. (Courtesy of the Keil family.)

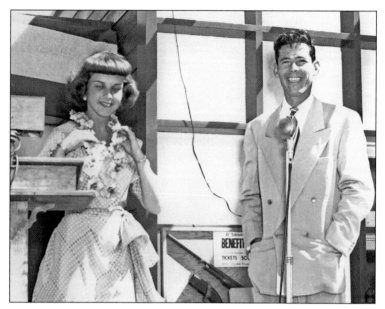

NEW FIRE STATION DEDICATION, JULY 10, 1949. The man pictured is Bill Oliver, president of the local Lions Club, and the woman is Patsy Lee, singer with a local band called McNeill's Breakfast Club. Patsy sang several songs and drew winning tickets for several prizes. The first-prize winner was L.E. Nail, who won the shotgun that is visible between Bill and Patsy. (Courtesy of the Oliver family.)

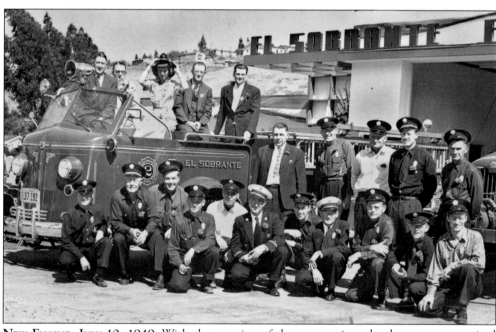

NEW ENGINE, JULY 10, 1949. With the opening of the new station, the department acquired this new American LaFrance. The man sitting in the cab by the siren is Wilbur Skow and Singer Patsy Lee is holding on to her hat. George Lehmkuhl is kneeling second from left with his son Melvin to his left. Lester Skow is the man standing by the truck at the left, and in the same row, Ed Campbell is standing second from right. According to Ed, the new truck was "all show and no go." (Courtesy of the Oliver family.)

FIRE STATION DEDICATION, JULY 10, 1949. The construction of the fire station in 1949 was a huge event in the life of the El Sobrante community. It was a visible sign that the town had achieved a certain critical mass and was deserving of a modern fire protection facility. The crowd in this photograph is listening to a speaker at the new station. The old building is in the background. (Courtesy of the Oliver family.)

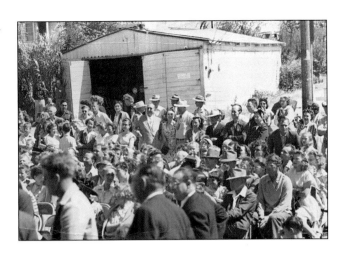

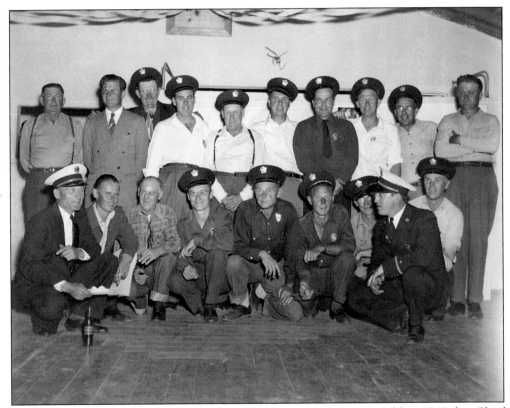

GROUP SHOT, EL SOBRANTE FIRE DEPARTMENT, c. 1949. It was not until late 1949 that Chief Matteson became the first paid member of the El Sobrante Fire Department, receiving $300 a month. Everyone else was an unpaid volunteer. In the front row, fourth from the left is Virgil Philippi, Bill Heide is sixth from left, and the man in front to the right is Chief Matteson. In the back row, the man second from the right is Ed Kamb, and the man to his right is Ed Campbell. (Courtesy of Edward Campbell.)

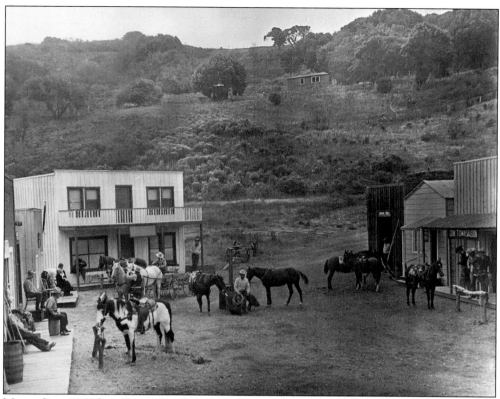

MOVIE SET, 3510 SAN PABLO DAM ROAD, C. 1948. The location of present-day Raley's Market previously served as a movie set. Rumor has it that some scenes shot here appeared in the movie *The Saddle Tramp* starring Joel McRea, which opened in 1950. Jess Nunes bought the set in 1949 and reassembled it at the old Weyhe Ranch. (Courtesy of Doraleen Nunes Andrade.)

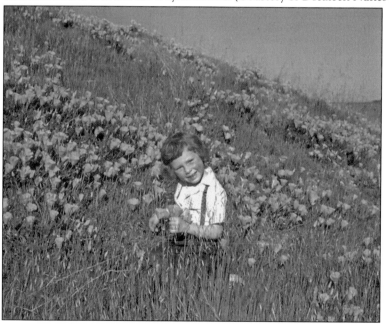

TERRY CAMPBELL, POPPY HILL, 1948. The hill at the top of Appian Way, where the Bay Park Senior Living Center is today, was well-known for its wild profusion of poppies in the spring. Pictured is Ed Campbell's daughter Terry. (Courtesy of Edward Campbell.)

Four

ALMOST A TOWN
THE 1950S

The 1950s were a boom time for El Sobrante. A look at almost any issue of the local weekly newspaper, the *Herald*, reveals an endless parade of new business openings, church or school dedications, and optimistic plans for ever more ambitious projects. The population growth was so rapid that confident predictions were made that the town would soon reach 40,000 or more. For the first time, the idea of incorporation was floated and vigorously supported by civic groups. While a Berkeley study in 1955 concluded that incorporation was "feasible," the issue was clouded by the annexation by the City of Richmond of large chunks of El Sobrante territory. This piecemeal chipping away, not only of the town's borders but its heart, led to a deep-seated suspicion of Richmond's intentions, which linger to this day. Eddie Galli, editor of the *El Sobrante Herald*, referred to Richmond as the "octopus," whose "tentacles" had snared "some of its choicest subdivision acreage . . . and its entire future taken out of the hands of its residents by the grasping, ambitious interests of Richmond." This harsh assessment was probably unfair, as the sentiment for incorporation was never strong among the nonbusiness residents, and such a move would likely have failed under the most favorable of circumstances.

A new phase in El Sobrante's development occurred with the construction of the Sherwood Forest subdivision in 1955, offering two-story homes with four bedrooms and two bathrooms. In the future, larger developments would become the norm. El Sobrante was quickly moving away from its rural roots and becoming a bedroom community. Also in 1955, another link to the past was shut with the closure of La Honda Bowl. What had been a recreational center since the 19th century was no longer around. Also, in the same year, the venerable Skow Dairy closed its doors. El Sobrante was growing up, but with that growth came inevitable loss.

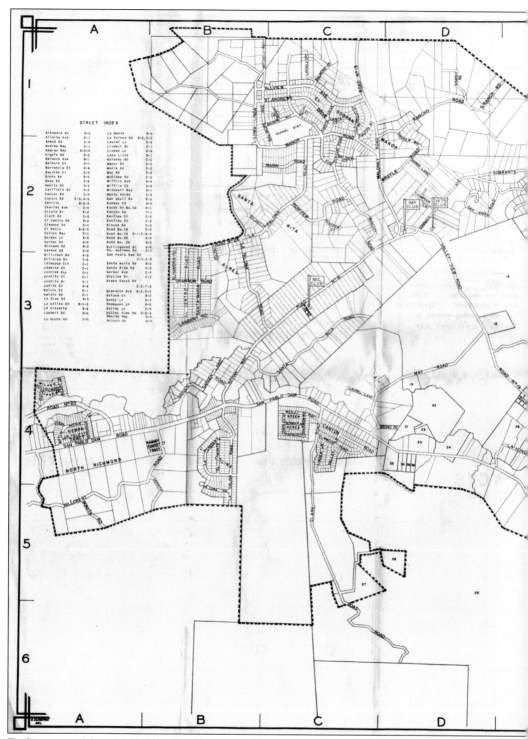

EL SOBRANTE MAP, 1950. The Fire Protection District was organized in 1944, and even today this map would fairly accurately describe the boundaries of the community. As of the date of this map, most of the development was located near San Pablo Dam Road, especially near the center

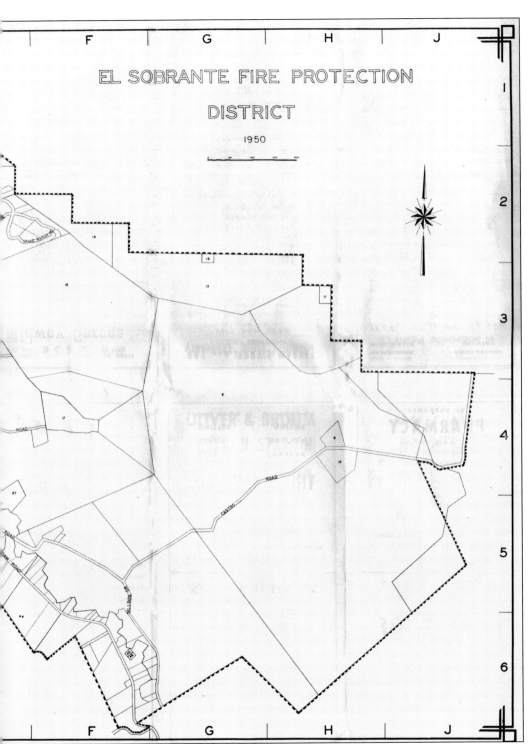

EL SOBRANTE FIRE PROTECTION

DISTRICT

1950

of the business district and in the hills off Appian Way. Appian Way from the intersection with Valley View is still called Maloney Way, in honor of pioneer Tom Maloney. Castro Road does not connect with Valley View, at the time called Road No. 19. (Courtesy of Jim Cowen.)

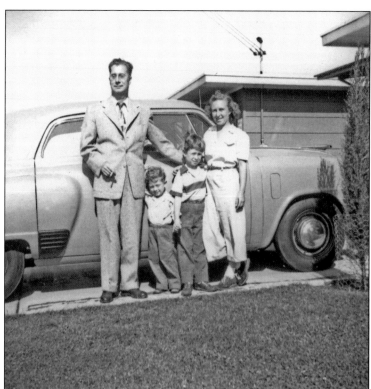

ROMANO FAMILY, RANCHO VISTA, JULY 1950. Vincent and Laura Romano moved to the new Rancho Vista development, known as the Serpa Tract in the late 1940s. Here, we see them with sons Kenneth, the oldest, and Dennis. Rancho Vista was one of El Sobrante's earliest developments, located just off San Pablo Dam Road, not far from the intersection with El Portal Drive, previously Road 20. (Courtesy of the Romano family.)

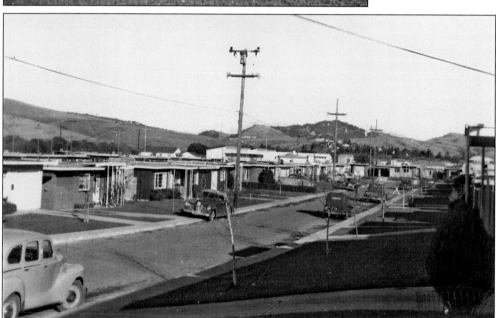

RANCHO VISTA HOUSING DEVELOPMENT, 1950. In the late 1940s, Earl "Flat-top" Smith built two housing developments in El Sobrante. Rancho Vista was just west of Rancho Elementary School. The other, called Canyon Park, was just off Clark Road. Nationally acclaimed builder Joseph Eichler was very much impressed by Smith's innovative designs and incorporated many features into his own, more expensive homes. (Courtesy of the Romano family.)

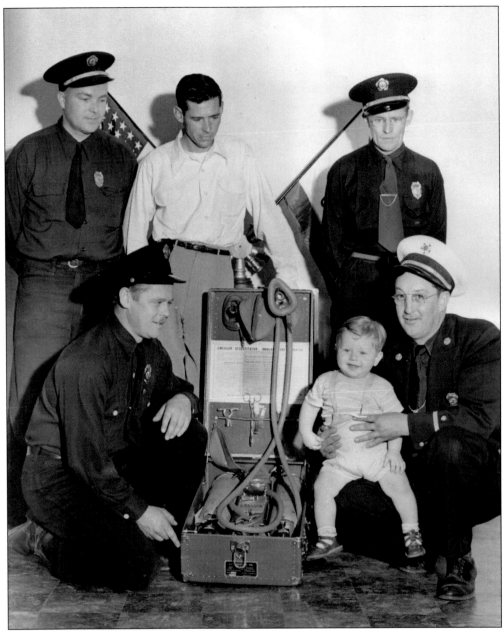

BABY SAVED WITH NEW RESUSCITATOR, JULY 1950. This resuscitator, donated by the Lions Club, was credited with saving the life of little Kenneth Neilson, who was close to death due to heat prostration. The man holding the boy is Chief Matteson. The kneeling fireman is Willard Hare. The three men standing are Joe Mansfield, Bill Oliver (Lions Club president), and John Huffman. (Courtesy of CCCFPD, Station 69.)

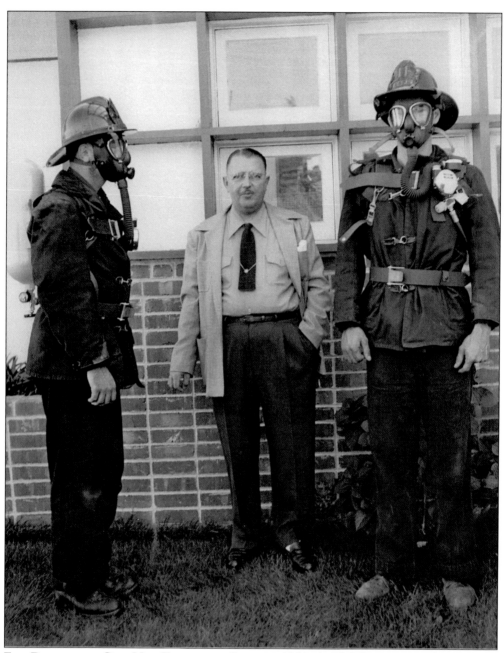

Fire Department Gets New Equipment, October 1950. As El Sobrante grew, the nature of the fire threat changed. Only a few years earlier, almost all of the calls had involved grass fires. Home fires demanded more sophisticated equipment. As usual, the El Sobrante department was at the forefront in this regard. These new masks costing $200 apiece enabled the wearer to remain in extreme conditions for up to 30 minutes. Pictured are fireman Raymond Reed (left), Fire Commissioner Leo Logan (center), and John Bressem. (Courtesy of CCCFPD, Station 69.)

LA HONDA BOWL SIGN, EARLY 1950s. From the late 1800s to the mid-1950s, La Honda Bowl served the community of El Sobrante as a place to hold parties, dances, celebrations, and picnics. La Honda Bowl was located near San Pablo Creek between Old Road No. 19, now D'Avila Road, and La Honda Road. Until 1955, it was the location of the annual fire department benefit dance. (Courtesy of Ed Rossman.)

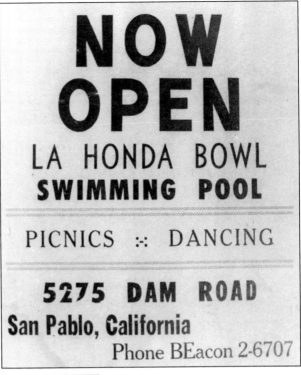

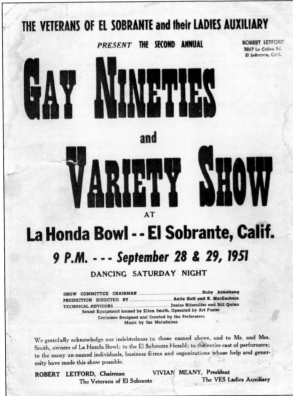

VETERANS CLUB EVENT, 1951. The La Honda Bowl site was popular with many local organizations, such as the Firemen's Association, or in this case, the local Veterans Club. This was the second-annual event for the Veterans Club and took up an entire weekend with a very extensive production list. (Courtesy of the Letford Family.)

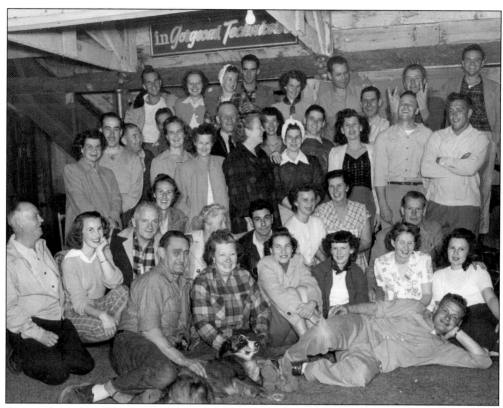

GROUP SHOT, LA HONDA BOWL, 1951. The La Honda Bowl site consisted of a stage, a dance floor, and a bar. Many people remember a slide that went from the bar to the dance area, which some think was put in during Prohibition in order to make a quick getaway. The donor of this photograph, Bob Letford, is standing at the far left with his wife, Flora. The owners of La Honda Bowl, Mr. and Mrs. Smith, are sitting in front with the dog. (Courtesy of the Letford family.)

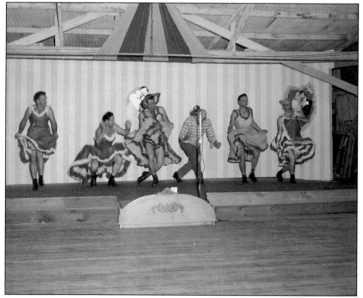

VARIETY SHOW, LA HONDA BOWL, SEPTEMBER 1951. The Veterans Club of El Sobrante put on this two-day event. At the time, men dressing in drag were a surefire hoot. The man at the far right is Bob Letford and next to him is Norman Dean. The fellow at the far left is Bill Boardman. The remaining three are Eugene Armstrong, Don Westgard, and John Kenney. (Courtesy of the Letford family.)

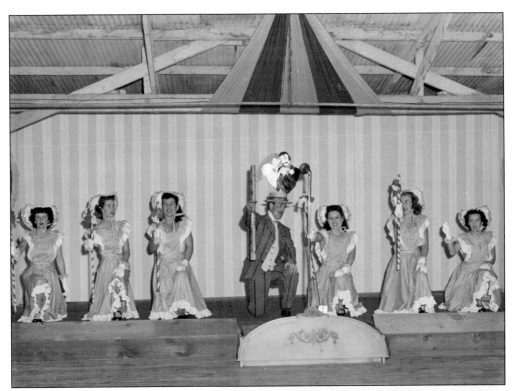

SONG AND DANCE, LA HONDA BOWL, SEPTEMBER 1951. Bob Letford is the man in the middle, leading the ladies in a rendition of "Waitin' for the Robert E. Lee" for this Veterans Club event. The women are Betty Morgan, Bonnie Anderson, Ruby Armstrong, Nadine Cross, Jeanne Updyke, and Vivian Meany. (Courtesy of the Letford family.)

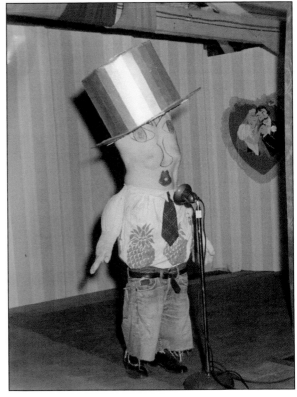

NOVELTY ACT, LA HONDA BOWL, SEPTEMBER 1951. Bob Letford created this costume and assures the author that it was a smash hit. The face is painted on his chest and stomach, while the head and arms are concealed in the hat. The visible arms are, of course, fake. (Courtesy of the Letford family.)

CLEANING THE SWIMMING POOL, EARLY 1950s. The La Honda Bowl pool was close to San Pablo Creek, and when the creek overflowed during heavy winter rains, the pool would be filled with muddy water. This photograph was probably taken in January 1952, when a particularly wet winter completely flooded this popular recreation spot. Firemen Al Valentine and Sparky Sanders are pumping out the pool. (Courtesy of Edward Campbell.)

CLASS AT SHELDON SCHOOL, C. 1951. The old Sheldon School along Castro Road, where the Sherwood Forest Freewill Baptist Church is today, closed in 1952 with the opening of the new Sheldon School on May Road. This was one of the last classes to attend the old school. In the front, second from left, is Richard Stanley. Sitting at the far right is Jim Keil. The lone African American girl is Rose Wheat. (Courtesy of the Keil family.)

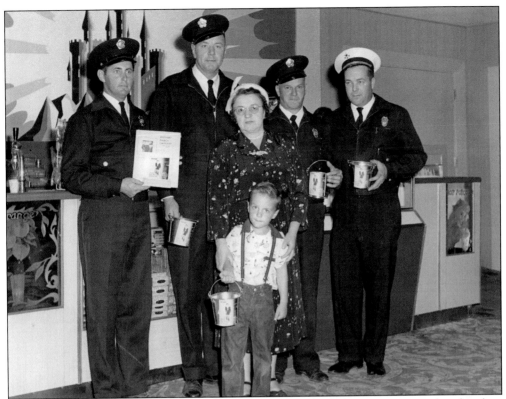

MARCH OF DIMES DRIVE, PARK THEATRE, JANUARY 1952. Chief Matteson, wearing the white hat, stands with his men in support of the annual March of Dimes drive to combat polio. The lady is Teresa Banducci, who chaired the March of Dimes drive for many years in the 1950s. The Park was frequently used as the site of community-supported events. The men are wearing Eisenhower jackets that were just purchased by the department. (Courtesy of the CCCFPD, Station 69.)

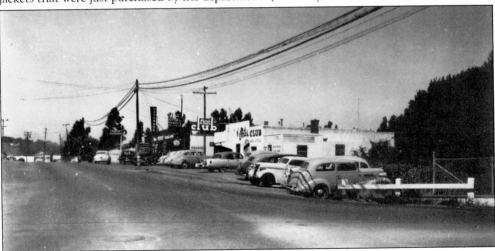

PETE'S CLUB, JULY 1953. Pete DeGeorgis and his wife, Jeanne, who owned the new Kaiser automobile parked in front of the club, ran this nightclub for several years. It was located just to the right of Oliver's Hardware Store, which is now a parking lot. In 1956, the club burned down, allowing Bill Oliver to expand his operation. (Courtesy of Paula Banducci Sanchez.)

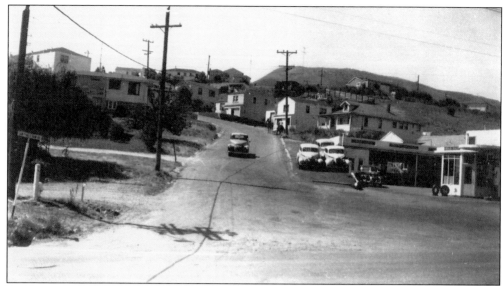

LA COLINA ROAD, JULY 1953. At the right is the Union 76 Station, built by John Oliver in 1946. The area along La Colina was one of the earliest to be developed, and many homes are built along this steep roadway. (Courtesy of Paula Banducci Sanchez.)

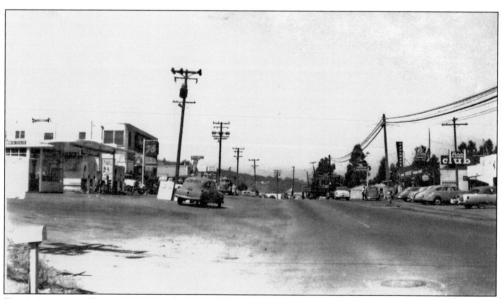

RAY'S MARKET, JULY 1953. Just beyond Oliver's Union Station is a grocery store operated by Ray Dickenson. Originally, the store had been owned by a man named Armstrong, but cousins Ray and Jerry Dickenson reopened the market around 1946 as Ray & Jerry's. Jerry left after a few years. It reopened as a Fry's store in the mid-1950s, and Ray went on to open LoRay's, combining his name with Loretta, his wife's name. (Courtesy of Paula Bancucci Sanchez.)

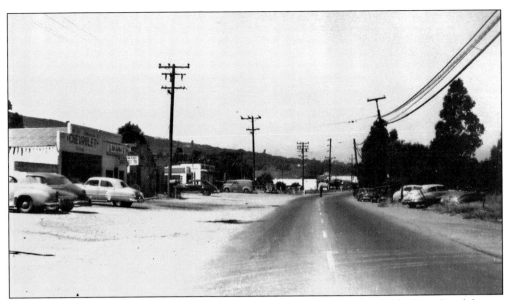

DOWNTOWN EL SOBRANTE, JULY 1953. This image looks west on San Pablo Dam Road from a spot just west of the intersection with Appian Way. San Pablo Dam Road was just two lanes at this time. Just up the street to the left is an automobile repair shop. There is still an automobile shop in this location, run by brothers Lyle and David Miller. (Courtesy of Paula Banducci Sanchez.)

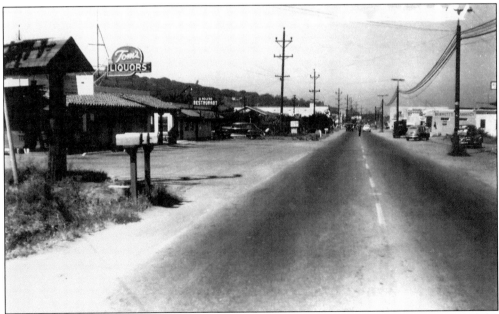

TOM'S LIQUORS, JULY 1953. Pete and Minerva Ogle opened Tom's Liquors in August 1950 (why the establishment was called "Tom's" is not clear). Tom's was also a restaurant. In 1961, new owner Len Battaglia reopened the business as Rancho Liquors. It is currently owned by John Oliver, son of Bill Oliver. The "El Bolero" restaurant opened in October 1951. (Courtesy of Paula Banducci Sanchez.)

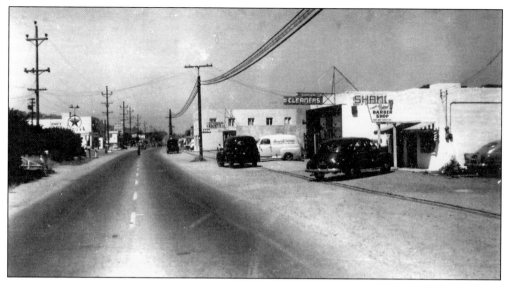

TOWN CENTER, JULY 1953. Albert Oliva and Ray Lesti were the proprietors of the Friend Barber Shop, now Sam's Dog House. Shangri-La Cleaners is now the home of Micro-Easy Computer Shop. The Hillview shopping center would later fill the space between the cleaners and the paint store, which is now home to the Kaliente restaurant. (Courtesy of Paula Bancucci Sanchez.)

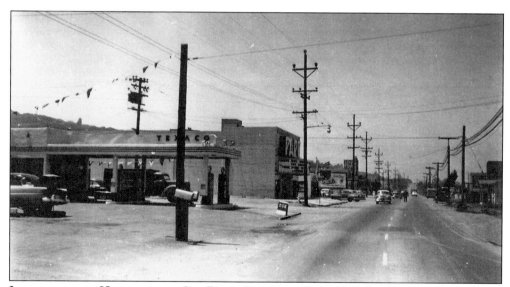

INTERSECTION OF HILLCREST AND SAN PABLO DAM ROAD, JULY 1953. Looking west, past the gas station across Hillcrest is the Park Theater, which first opened in 1949. Further down the road on the left, the Louis Store sign can be seen. This store originally opened as the Fairway Market two years earlier. It provided service, noted the *El Sobrante Herald*, "not available heretofore, in this area." (Courtesy of Paula Banducci Sanchez.)

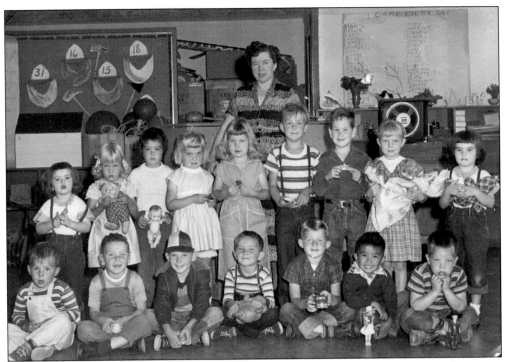

EL SOBRANTE ELEMENTARY SCHOOL CLASS, 1953. Located on Manor Road, El Sobrante Elementary School opened in January 1950. El Sobrante Elementary No. 2 opened in December 1953 on Valley View Road, but the name was changed to Marie A. Murphy Elementary just two years later in honor of a local teacher. Kenyon Chan is the boy sitting on the floor, second from right. (Courtesy of Martha Chan.)

EL SOBRANTE VETERANS CLUB EVENT, MARCH 1954. At this date, the Veterans Club of El Sobrante met in a small building along Appian Way, on the side opposite to the fire station. In this photograph, Bob Letford is the bartender. The two people at the end of the bar looking at the camera are Stan Carter and Joyce Grimani. (Courtesy of the Letford family.)

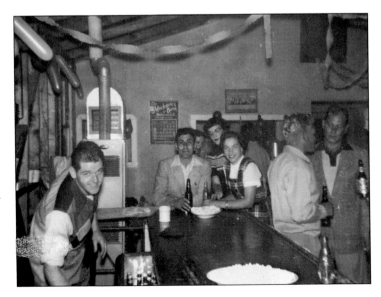

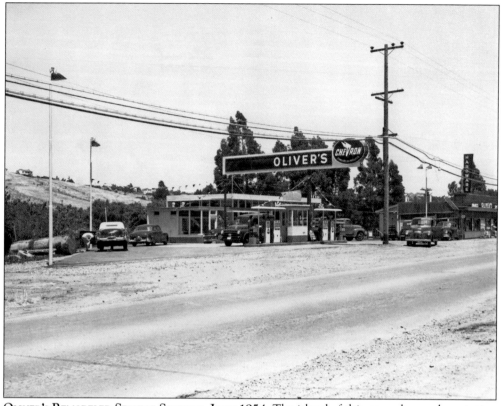

OLIVER'S REMODELED SERVICE STATION, JUNE 1954. The island of this new, ultramodern station was, according to its owner, "the longest in the entire Richmond, San Pablo, and El Sobrante area." The pumps were formerly in front of the hardware store, but the widening of San Pablo Dam Road to four lanes necessitated their being moved. (Courtesy of the Oliver family.)

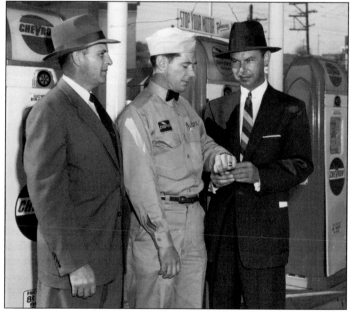

BILL OLIVER WINS AWARD, MARCH 24, 1955. Bill Oliver is receiving a wristwatch from these Chevron officials, who look like something out of *Dragnet*. In competition with 433 other local dealers, his sales performance was consistently at the top. In 1953, he received an all-expense-paid trip to New York, but after two more years of superior performance the Chevron Company apparently felt that a wristwatch was sufficient. (Courtesy of the Oliver family.)

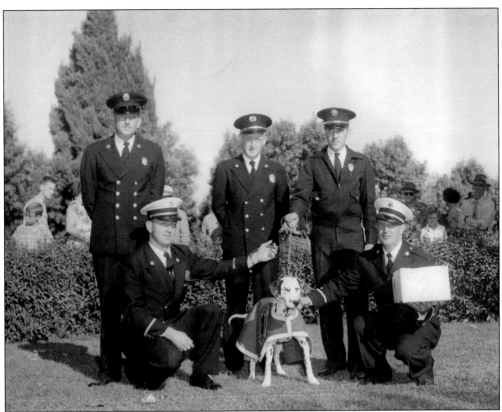

DUKE I, FIRE DOG, c. 1953. In the early 1950s, the El Sobrante Fire Department had its own firedog, a Dalmatian. Duke was a favorite at local dog shows. Here, he is photographed with Chief Matteson, kneeling right with a box in his hand. Behind the chief is the assistant chief, Harold Huffman. Duke loved to ride on the engines to a fire, with the sirens blaring. His enthusiasm, unfortunately, caused him to be struck by one of the trucks and he was severely injured. Sadly, he had to be put down. (Courtesy of CCCFPD, Station 69.)

DUKE II, NOVEMBER 1954. Shortly after the death of Duke I, the El Sobrante Merchants Association presented the fire department with this replacement, another thoroughbred Dalmatian, and a first cousin to the original Duke. Unfortunately, Duke II never displayed enthusiasm for the job, and he was quietly retired. Pictured are Leonard Spafford (left), Harold Huffman (center), and Chief Matteson. (Courtesy of Harold Huffman.)

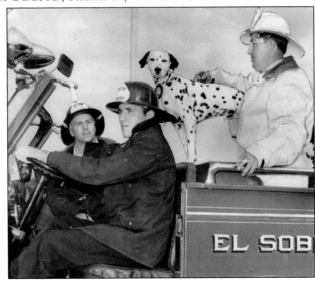

SUPPORT YOUR LOCAL FIRE DEPARTMENT, JULY 1954. Every year during late summer, the El Sobrante Fire Department would hold a benefit dance to raise money for the station. This was a very popular and well-supported event. There was always a picture (usually with a pretty girl) and article in the local *El Sobrante Herald*. Pictured from left to right are Judge Wilson Locke, Sharon Olson, and Melvin Lehmkuhl. (Courtesy of Harold Huffman.)

INTERSECTION OF VALLEY VIEW AND MAY ROADS, c. 1955. Looking east down Valley View Road, the brand-new De Anza High School is on the right with its Quonset hut gym. At the bottom of the hill at the intersection is the Lucksinger Dairy, where the Lucky Store would later be built. Across the street are the remnants of what may have been the old Wilkie Ranch. (Courtesy of Edward Campbell.)

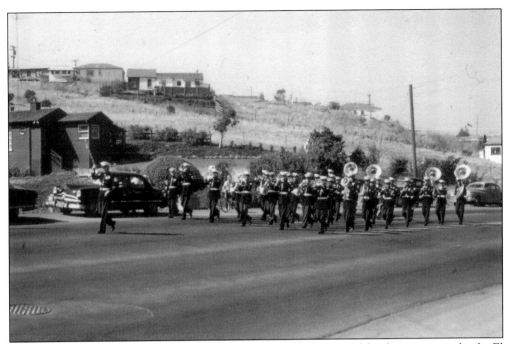

MARINE CORPS BAND, DAM ROAD, SEPTEMBER 10, 1955. The annual fundraising event for the El Sobrante Fire Department in 1955 was a three-day affair, with the highlight being a parade down San Pablo Dam Road from St. Callistus Catholic Church to the Sheldon School on May Road. The Marine Corps band is pictured, just passing Appian Way. (Courtesy of Edward Campbell.)

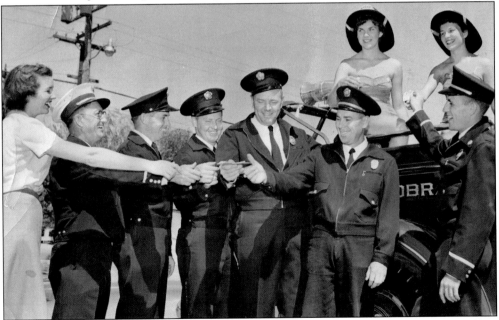

ANNUAL FIRE DEPARTMENT PUBLICITY EVENT, 1955. Pictured here from left to right are (first row) Sylvia Kinsolving, Chief Charles Matteson, Bill Helms, Dave Chandler, Don Westgard, Bob Lowrie, and Harold Huffman. The two young women in the engine cab are Marilyn Sorenson (left) and Sharon Swanson. (Courtesy of Harold Huffman.)

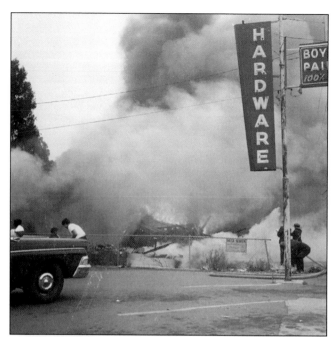

PETE'S CLUB BURNS, AUGUST 15, 1956. Two days before, two smaller fires had been extinguished by the El Sobrante Fire Department. So when this third fire effectively destroyed the nightclub, arson was suspected. Suspicion settled on Jeanne DeGeorgis, wife of the owner Pete DeGeorgis. She was arrested and tried, but due to lack of sufficient evidence was acquitted. (Courtesy of the Oliver family.)

SHELDON SCHOOL, 1956. The Sherwood Forest Freewill Baptist Church purchased the old Sheldon School in 1956. This school had been built in 1932 and was the last of five school buildings to be used at this site. The idea was to transform the old school into a church. (Courtesy of Sherwood Forest Freewill Baptist Church.)

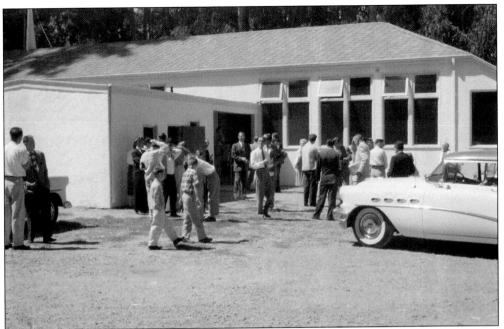

FIRST SERVICE, SHERWOOD FOREST FREEWILL BAPTIST CHURCH, AUGUST 26, 1956. The old Sheldon School was completely renovated by the church's congregation and ready for use in a little over two months. A brand-new sanctuary (church) was built in the 1960s, and the old Sheldon School and Church was torn down. (Courtesy of El Sobrante Freewill Baptist Church.)

SOAP BOX DERBY, OCTOBER 19, 1957. This was the fifth-annual Cub Scout race held by local Cub Scout Pack 133. Competitors raced down Valley View Road from Murphy School. "It was very steep . . . at least it looked very steep to a 10-year-old," recalls Kenyon Chan, second-place winner (right). Mike Thomas took first place. The comely lasses congratulating their heroes are Kathy Gannon (left) and Carol Ann Flanagan. (Courtesy of Martha Chan.)

GENE AND MARTHA CHAN, OCTOBER 19, 1957. This picture was taken along Manor Road by the little market that the Chans operated from 1952 to 1988. Their son Kenyon is in the coaster. With their two other children, Darlene and Darrow, Gene and Martha were very involved with their neighborhood and PTA and Scouting activities, and are still fondly remembered by local residents. Manor Market is still in business. (Courtesy of Martha Chan.)

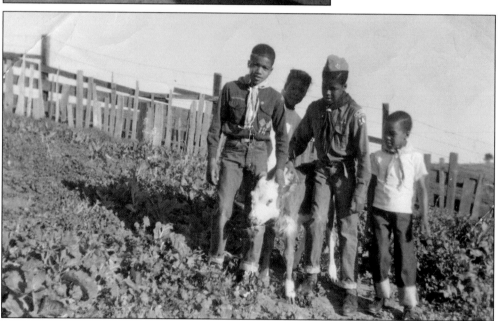

WHEAT CHILDREN, C. 1957. Wilbert and Vesper Wheat moved to El Sobrante in 1949, becoming perhaps the pioneer African American family in the community. They purchased three acres just off San Pablo Dam Road, near the intersection with Castro Road, now Valley View Road. This image shows, from left to right, Harry, Henry, Ruth, and Walter. The family had a large garden and many farm animals. (Courtesy of the Wheat family.)

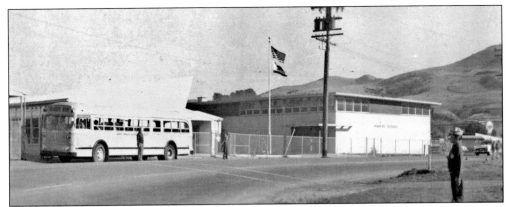

TRAFFIC PATROL, RANCHO SCHOOL, 1957. Rancho Elementary School was located on the east side of El Portal Drive, the old Road 20, just to the north of San Pablo Dam Road. It opened in 1950 and served the community for 30 years. The traffic patrol was taken very seriously by the students, who dressed in regulation uniforms and discharged their duties with almost military precision. (Courtesy of the Romano family.)

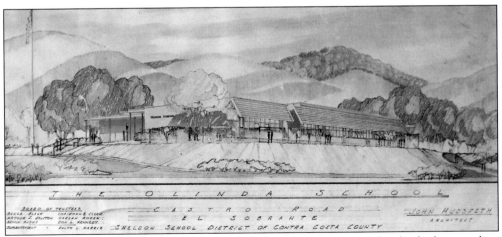

ARCHITECT'S DRAWING, OLINDA SCHOOL, 1957. Olinda Elementary School, which opened on December 1, 1957, was built on the site of the old Castro Ranch rodeo grounds. It was also the site of the town of Olinda, once planned as a community along the old C&N Railroad line. Many schools in El Sobrante have come and gone, but Olinda remains, though it has often been threatened with closure. (Courtesy of Olinda Elementary School.)

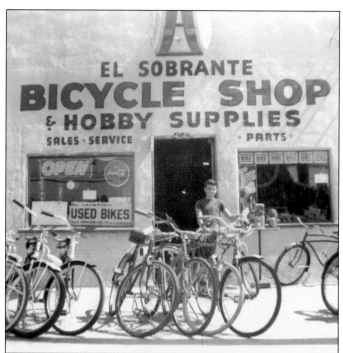

Bob Letford's Bicycle Shop, 1958. Bob Letford opened this shop on November 1, 1957. The location was 4040 San Pablo Dam Road, roughly across the street from Oliver's Hardware Store. He started with $500, and he purchased a few Schwinn bikes. His son Gary is standing in front. He later moved to his current location on El Portal Drive. (Courtesy of the Letford family.)

El Sobrante United Methodist Church, 1959. Established in 1940, this was one of the earliest churches in El Sobrante. A house served as a meeting place until 1949, when a new church was built on Appian Way, across from the intersection with Santa Rita Road. The congregation moved to their new home (above) in 1959. Pictured from left to right are Mildred Carden, Noble Justice (contractor), Tom Philippi, Rev. Noel Carden, and Mrs. Ben Harvey. (Courtesy of El Sobrante United Methodist Church.)

IRA AND IRENE GREENE, LATE 1950s. Ira Greene moved to Richmond from Arkansas to work in the shipyards in 1942, and the family followed in 1943. In 1952, the Greene family moved from the projects in Richmond to El Sobrante, in the Canyon Park development. The Greenes are seen here in their home at 3851 Linden Lane. Along with the Wheat family, the Greenes are among the pioneer African American families to settle in El Sobrante. (Courtesy of the Greene family.)

GREENE CHILDREN, 1958. Pictured from left to right are Ed, Ted, John, Mildred, and Carolyn. Twins Ed and John entered the brand-new De Anza High School as ninth graders in 1955 and soon made a name for themselves in sports and the social life at the school. Ed went on to a career as a basketball coach, mainly at Contra Costa College, and was inducted into the California Community College Basketball Hall of Fame in 1999. He is still coaching at CCC and still calls El Sobrante home. (Courtesy of the Greene family.)

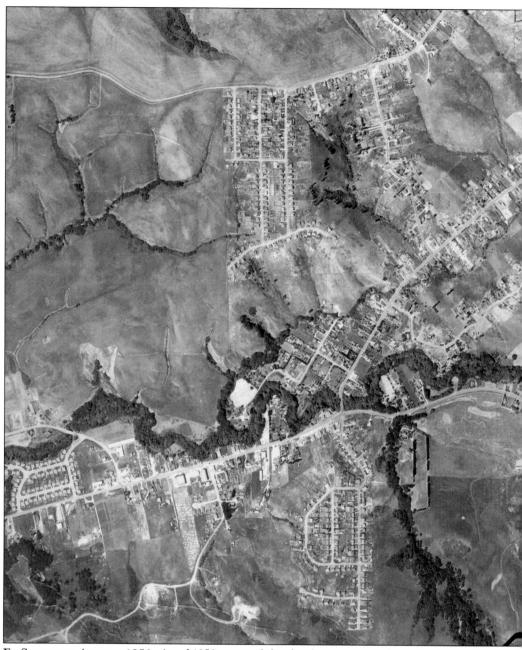

EL SOBRANTE AERIAL, 1950. As of 1950, most of the development was along San Pablo Dam Road and along, or off Appian Way. At the bottom left is the Rancho Vista development, completed in 1948. A little farther on, just off El Portal Drive (Old Road 20) is Rancho School, only partially completed. Further on, Appian Way moves diagonally to the left, with Santa Rita Road branching off to the right. Note that it ends abruptly at the top of the hill. To the right of the Appian Way intersection is La Colina and the extensive development off La Crescenta Road.

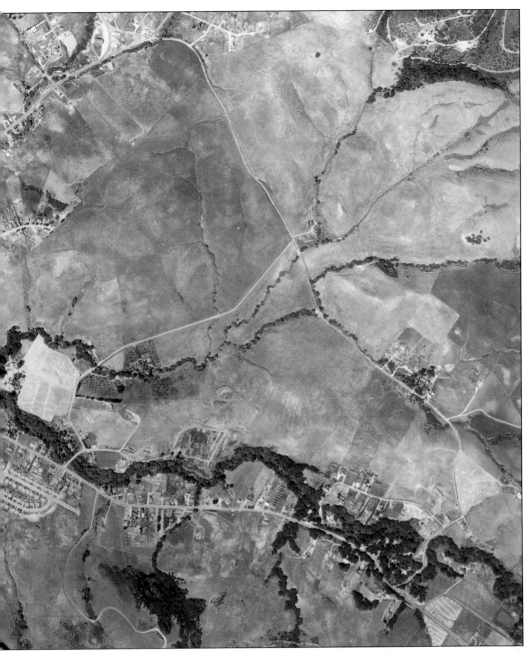

Just beyond Appian Way, on the right, the large empty patch is the Skow Dairy, with the ranch houses just to the west of Clark Road. On the east side of Clark Road is the new Canyon Park development. The intersection of San Pablo Dam Road and May Road can be seen just at the end of the Canyon Park project. Grading for the new Sheldon School is very prominent; otherwise, very little development is visible along May Road. (Courtesy of John Koepke.)

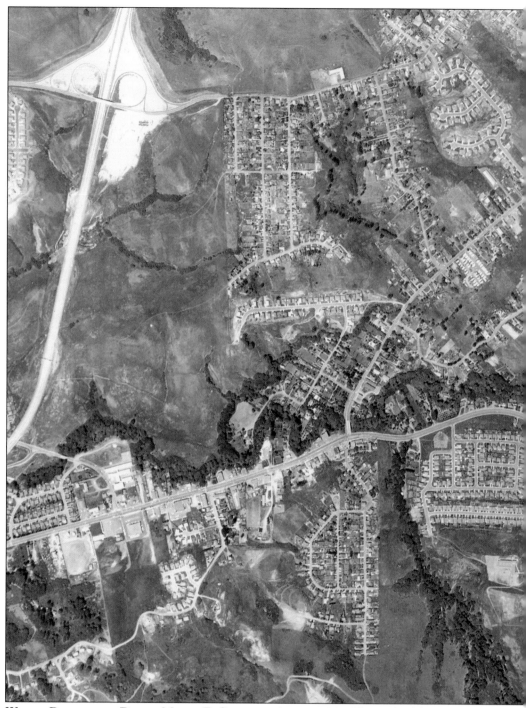

WHAT A DIFFERENCE A DECADE MAKES, EL SOBRANTE AERIAL, 1959. The result of the rapid growth of the 1950s is readily apparent. At the left is the new freeway that opened in 1956. Santa Rita Road now connects to May Road, bisecting the huge new housing development that completely covers the hillsides to the west of De Anza High School, which opened in 1955. Opposite the

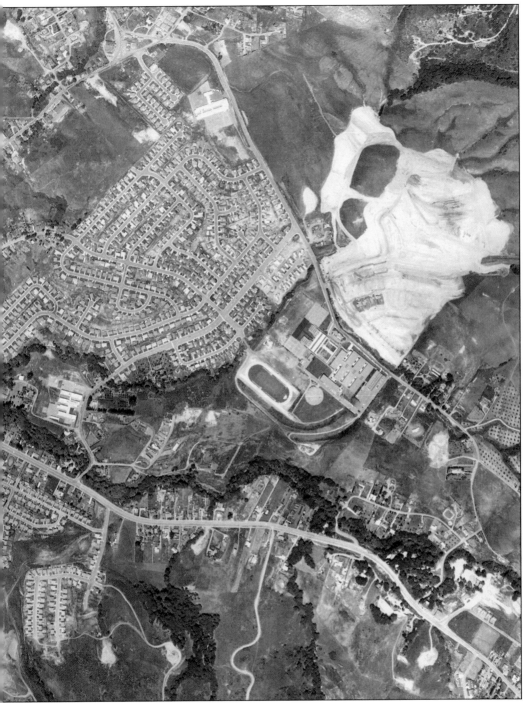

new school, a large area is being graded for even more housing. Back down to San Pablo Dam Road, just past Appian Way, a new housing development, Green Acres, has filled the area that was once the site of the Skow Ranch. (Courtesy of John Koepke.)

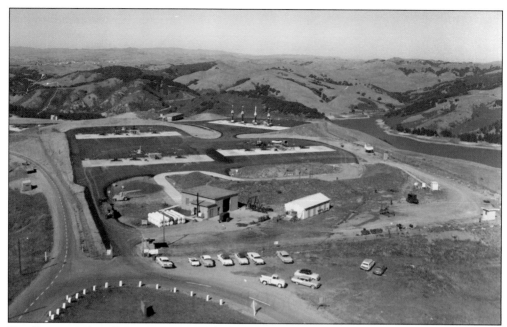

THE RUSSIANS ARE COMING, C. 1959. The hills above El Sobrante were once home to this Nike-Ajax missile installation, designed to protect the Bay Area from Soviet bomber attack. This view is northwest, with the San Pablo Reservoir in the background. Technological progress quickly made this facility obsolete, and by the early 1970s only the concrete radar pads remained. The access road is now a popular hiking trail. (Courtesy of El Cerrito Historical Society, Randy Cava.)

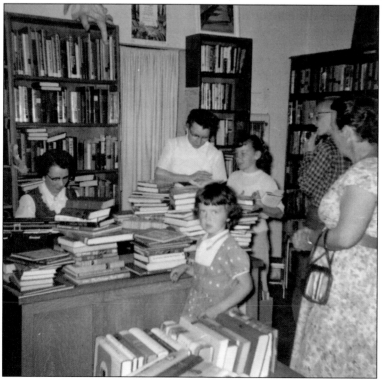

EL SOBRANTE LIBRARY, C. 1959. The El Sobrante Library was established in 1948. During the 1950s, the library was located in a room in the Mitchell Building, at the corner of Valley View Road and Appian Way. Here, the librarian, Thea Babbitt, is behind her desk, dealing with a typical evening crowd. (Courtesy of Contra Costa County Library.)

Five

BUSINESS AND PLEASURE
THE 1960S

During the 1960s, El Sobrante continued to grow. Such was the perceived demand for goods and services that no fewer than six large grocery stores were in operation. Finally, after years of planning and striving, a new branch library opened. This event was comparable to the fire station opening over a decade before, and was further evidence of the community's maturing. Since its opening in 1961, the library has established itself as perhaps the most central element in the life of the town, where community business is carried on.

Another important event was the opening of Kennedy Grove in 1967. The community now had a park it could call its own. To be strictly fair, the park is within the domain of the East Bay Regional Park District. However, like the San Pablo Reservoir, the local community wholeheartedly adopted the site, which had long been used by residents before it became a legitimate park. In many ways, it was the opening of Kennedy Grove that finally broke the logjam that had frustrated the reservoir's opening, which would finally take place in the following decade.

While the population was growing, the rate was probably nowhere near the optimistic estimates of the prior decade. In 1966, the guesses as to the actual population ranged from 8,000 to 15,000. An actual count done that year by volunteers resulted in a number around 10,400. It should be noted that this figure does not include those parts already annexed to Richmond. As far as ethnic composition is concerned, El Sobrante was finally beginning to move away from what had been an almost all-white population at 99 percent in 1960, moving toward something that reflected the reality of the rest of the Bay Area.

OLD EL SOBRANTE LIBRARY, MITCHELL BUILDING, 1960. From 1949 until the new library building was constructed in 1961, this was the site of the El Sobrante Library. Business increased steadily throughout the 1950s, and the facility was upgraded to the status of a full-fledged branch of the Contra Costa Library system in 1956. Today, the building still stands. (Courtesy of Contra Costa County Library.)

NEW LIBRARY SITE, 1960. Under the terms of a joint agreement, the City of Richmond agreed to purchase this orchard at the corner of Appian Way and Garden Road while construction and operation of the new library would be the responsibility of Contra Costa County. At last, the community of El Sobrante would have a dedicated library building. (Courtesy of Contra Costa County Library.)

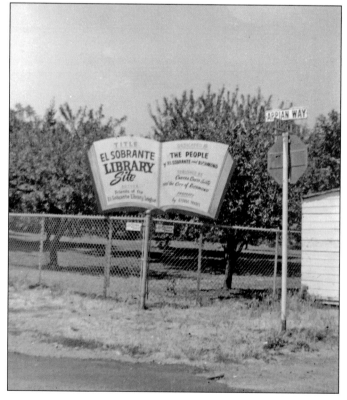

GROUND BREAKING,
EL SOBRANTE LIBRARY,
NOVEMBER 28, 1960.
Pictured from left
to right are Antone
Goyak (contractor),
Jim Kenny (county
supervisor), Arvil Miner
(El Sobrante Library
League president),
Bertha Hellum
(county librarian),
Emil Esola (chairman
of the Richmond
Library Commission),
Coit Coolidge (head
Richmond librarian),
and R.S. Chang
(project architect).
(Courtesy of the Contra
Costa County Library.)

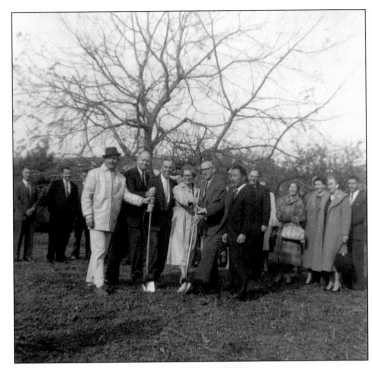

DONALD BASTIN,
SHERWOOD FOREST,
c. 1960. The
Bastin family moved
into their home at
5849 Robin Hood
Drive in the new
Sherwood Forest
development in
1955. The house,
with four bedrooms
and two bathrooms,
was a far cry
from the typical
two-bedroom and
one-bath unit
that most locals
were used to. The
1930 Model A
Ford coupe was a
14th birthday gift
in 1957 that cost
$60 at the time.
(Author's collection.)

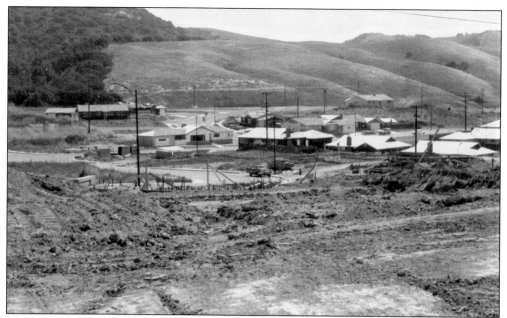

HOME CONSTRUCTION, FIELDCREST AND STEWARTON, 1960. The curved road in the foreground of this northeast-looking photograph is Fieldcrest, and the intersection behind it is Stewarton. This area, just off the newly-extended May Road, was just being developed. The hills are still clear of development. (Courtesy of the Loynd family.)

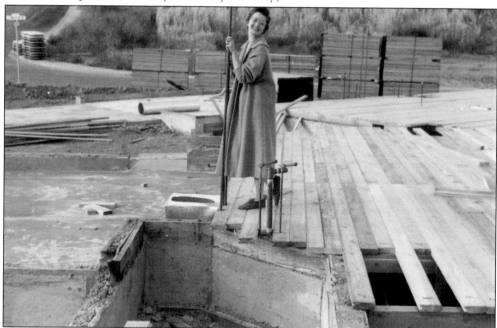

ELEANOR LOYND, NEW EL SOBRANTE HOME, 1960. Bob and Eleanor built their new home on Fieldcrest Drive in the Richmond area of El Sobrante. Eleanor has long been active in the community, particularly in the El Sobrante Valley Planning and Zoning Committee, to which she was appointed secretary in 1975. She is currently president of the committee. Though Bob has passed on, Eleanor still lives in the same home on Fieldcrest Drive. (Courtesy of the Loynd family.)

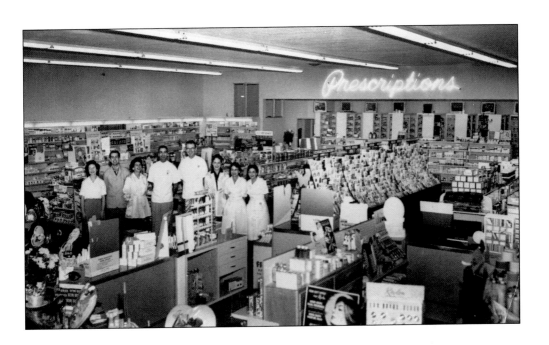

GRAND OPENING, PARK REXALL PHARMACY, FEBRUARY 16, 1961. The Jeha family was very important to the development of business in El Sobrante. Since 1955, pharmacy owner Bob Jeha (top, center, left) had operated a small pharmacy attached to the Park Theatre, which was owned by his brother Dick. In 1961, he expanded to this new facility. Pictured above from left to right are Lillian Lesher, Tim Miller, Maxine Conrad, Bob Jeha, Ade Gensul, Jo Evans, Lolli Olsen, and Virginia Thorsted. The photograph below shows the outside of the building around the same time. The business is still run by members of the Jeha family and looks the same. (Courtesy of the Jeha family.)

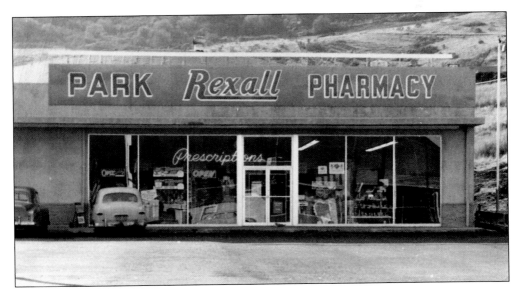

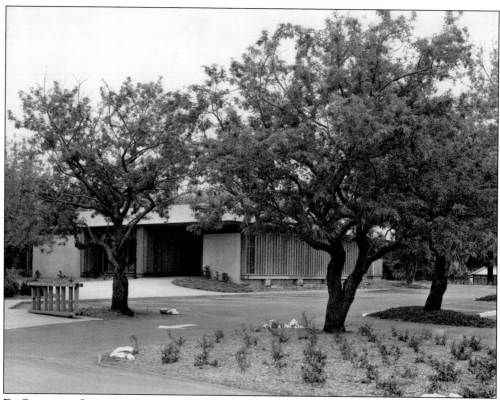

EL SOBRANTE LIBRARY, APRIL 1962. The new library was opened in June 1961. The above photograph shows the outside and the original entrance, which has not changed drastically since then. The photograph below shows what the inside of the library looked like before additional shelving was put in, significantly decreasing the seating area, and long before the library was expanded in the mid-1970s. The pre-expansion library also seems to have had significantly more window area and consequently more natural lighting. (Courtesy of the Contra Costa County Library.)

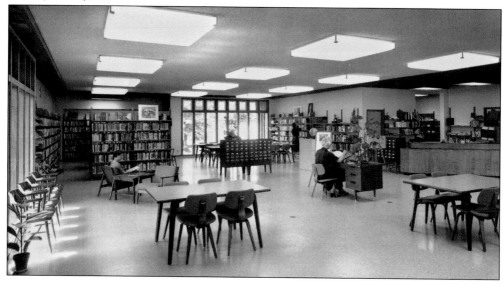

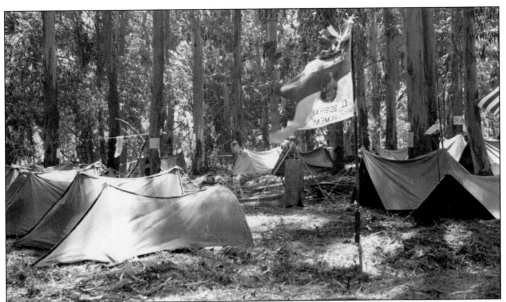

SCOUT CAMPOREE, KENNEDY GROVE, EARLY 1960s. Approximately 600 to 700 scouts attended these three-day competitive scout camping events. Scouts came from all over Contra Costa County, and prizes were awarded for superior "scoutcraft" and camping techniques. The eucalyptus grove below the dam was the usual site for these events, now called Kennedy Grove, in honor of the late president. (Courtesy of CCCHS.)

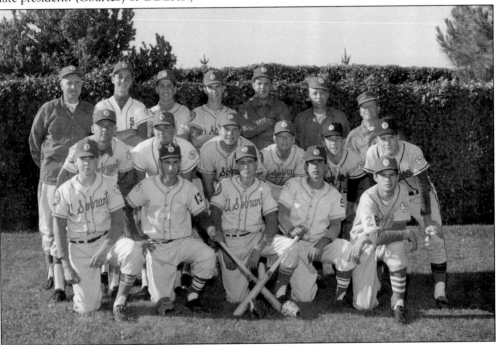

EL SOBRANTE ALL-STARS, AUGUST 1962. Local boys ages 15 and 16 won the Colt League pennant in 1962. These all-stars wearing the El Sobrante uniform played in the state tournament in Sacramento that year. Sadly, they did not win. The manager is Ernie James, seen in the back row, second from the right. (Courtesy of Steven James.)

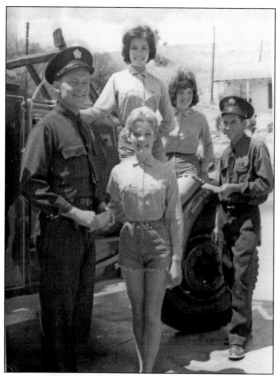

"The Last Wagon West," August 1962. On October 1, 1961, the Gillis family left Richmond, Virginia, in a homebuilt covered wagon, en route to El Sobrante. The family had long talked about coming to California, and Mrs. Gillis had a sister living in town. The trip took months and was covered in the news, especially in the *Herald*. Family members became local celebrities, and three of the four girls helped to sell tickets to the firemen's annual ball. In the above photograph, fireman Loren Olsen is handing a ticket to Lee Ann Gillis, while Bill Lenzi is at the right. The two sisters on the engine fender are Carol (left) and Barbara. The three young women pose for another publicity shot below. (Courtesy of CCCFPD, Station 69).

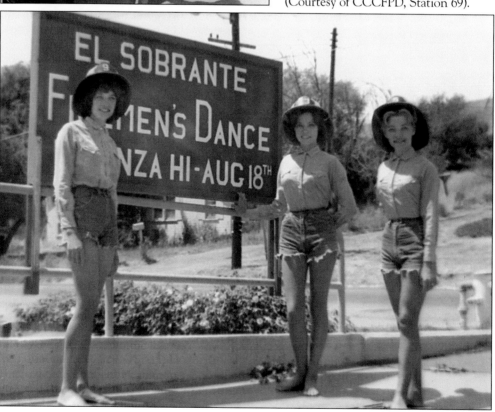

HILLSIDE DRIVE AND HEIDE COURT, 1963. Hillside Drive is an old road that runs along San Pablo Creek, ending at Kennedy Grove. Until 1963, only the creek side of Hillside Drive had been developed. The hills along the northeast side of the road had remained untouched. Heide Court was built to accommodate additional new housing that was anticipated. Undeveloped lots were sold and the owners built to their own taste; therefore, the homes are all different. (Courtesy of the Keil family.)

CANYON POOL, 1965. As of 1965 when this poster was printed, the Canyon pool located on Campbell Lane had been in business for 14 years. The pool got its start in the Canyon Park development in 1951, when Craig Ortleib built a pool in his backyard at 4615 Canyon Road, and began offering swimming lessons. The business moved across San Pablo Dam Road to its present location in 1960, and the pool is still very much in business. (Courtesy of Canyon Pool.)

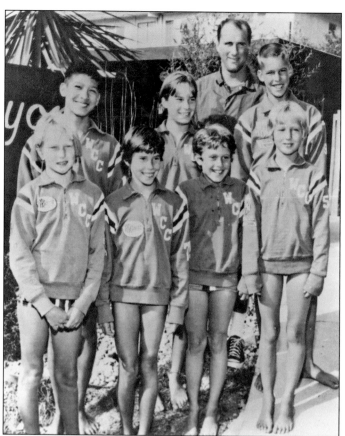

CANYON POOL SWIM TEAM, C. 1965. Bill Brown was the swim coach. The children are, from left to right, (first row) Kathy Sabec, Julie Johnson, Leslie Defoe, and unidentified; (second row) Rick Klump, Jill Miller, and Granville Smith. (Courtesy of Canyon Pool.)

WILKIE RANCH, 1965. Charles Wilkie was one of El Sobrante's pioneers. In the late 1800s, he purchased 107 acres along a little tributary of San Pablo Creek, along what is now May Road. Though nothing remains of his ranch today, his name lives on, attached to the pretty little creek that runs along the west side of De Anza High School. (Courtesy of CCCHS.)

WOLFRAM RANCH, MAY ROAD, 1965. J. Wuhlfram was one of the early landowners in El Sobrante. A 1900 map shows that he owned a little over 55 acres along Wilkie Creek, near the Wilkie Ranch. This parcel is now the site of the Hope Lutheran Church. (Courtesy of CCCHS.)

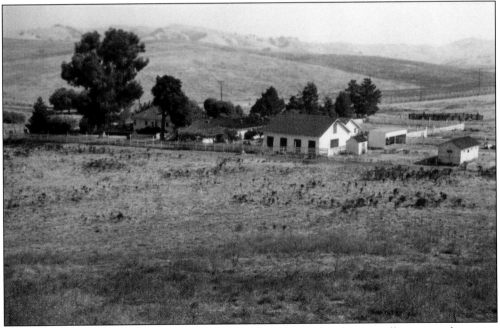

O'NEILL RANCH, CASTRO RANCH ROAD, 1965. The O'Neill family was well connected to many other old-time El Sobrante pioneers. This photograph looks north, with Castro Ranch Road defined by the fence posts toward the upper right. Today, the site is completely covered by the Carriage Hills South housing development. (Courtesy of CCCHS.)

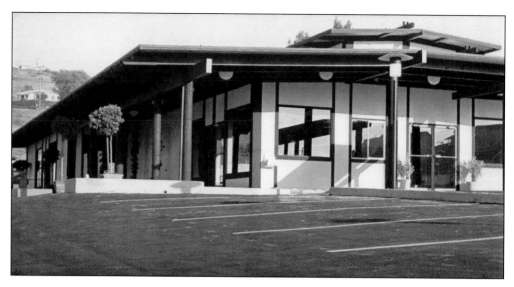

ADACHI NURSERY, 1967. The Adachi family had long operated a nursery in El Cerrito on San Pablo Avenue. In 1967, they moved to El Sobrante, building a new facility at the bottom of the hill along Valley View Road at the intersection of Sobrante Avenue. The photograph above shows the facility just after construction. The lower photograph features the nursery a few years later, in full operation. On the left is the Horseshoe Café and Bar, which operated at this location beginning in the late 1940s. With the later widening of Valley View Road to four lanes, the old landmark was torn down. (Courtesy of Adachi Florist and Nursery.)

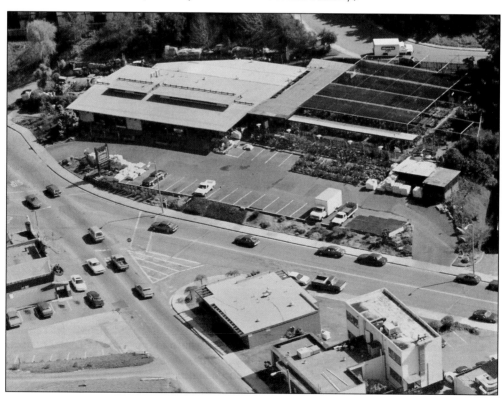

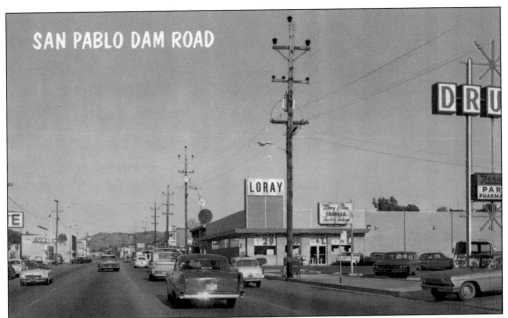

DOWNTOWN EL SOBRANTE, C. 1966. The LoRay store opened late in 1965 in the old Louis Store building. This business was founded by Loretta and Ray Dickenson. During the 1960s, no fewer than six large grocery stores were operating in El Sobrante, including LoRay, Fry's, Safeway, Lucky, 7-Oaks, and the Calico Market. Only the Calico Market, now named Central Market, remains. (Courtesy of Lynn Maack, Sandi Genser-Maack.)

KENNEDY GROVE DEDICATION, OCTOBER 22, 1967. State senator George Miller Jr. was the keynote speaker at the opening of this new addition to the East Bay Regional Park District. Music was provided by the Richmond Symphony and the Salesian High School Band. Local boy scouts provided a camping exhibit and raised the flag. (Courtesy of CCCHS.)

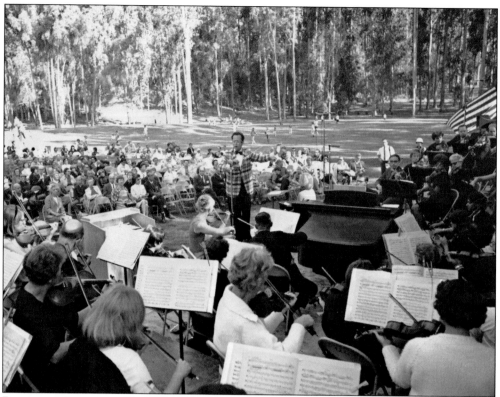

RICHMOND SYMPHONY, KENNEDY GROVE DEDICATION, OCTOBER 22, 1967. William Jackson is the conductor at this event. Originally planned for the summer, the construction took longer than planned. This late date caused a concern that rain might drown the event, in which case everything would have been moved to De Anza High School. Luckily, the weather was fine. (Courtesy of EBRPD.)

SEN. GEORGE MILLER JR. WITH JOHN BRIONES, OCTOBER 22, 1967. The ceremony at Kennedy Grove also celebrated the opening of Briones Regional Park. John "Toddy" Briones was a descendant of the original Briones family that once owned the Briones parkland; he was 94 years old at the time. George Miller is the father of current congressman George Miller III. (Courtesy of EBRPD.)

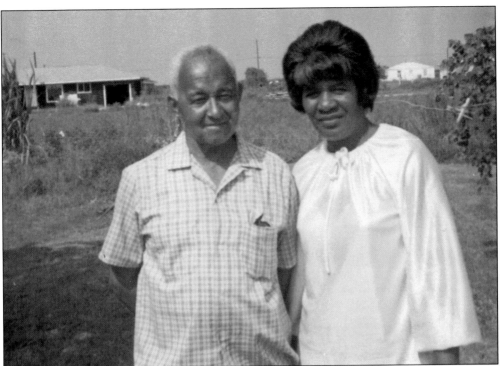

WILBERT AND VESPER WHEAT AT HOME, 1969. The Wheats moved from Louisiana to Richmond in 1942 to work in the shipyards. They lived in the Harbor Gate housing complex for about six years before moving to El Sobrante. Both had been raised on a farm and wanted land to raise vegetables and animals. They bought three acres just off San Pablo Dam Road by Castro Road. Vesper, now 90 years old, still lives in the home that they built. (Courtesy of the Wheat family.)

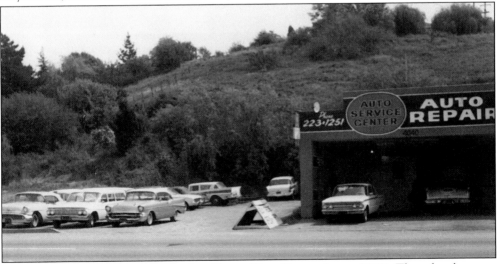

AUTOMOBILE REPAIR SHOP, 4040 SAN PABLO DAM ROAD, APRIL 1968. There has been an automobile repair facility at this location for at least 60 years. At this time, used cars were also sold here. The price on the 1957 Chevrolet in front was $425. The current business at this location is El Sobrante Wheel & Brake, run by brothers Lyle and Dave Miller. (Courtesy El Sobrante Wheel & Brake.)

THODE HOUSE, VALLEY VIEW ROAD, 1968. Though it has been modified through the years, this is the original house built by H. Nicholas Thode in 1880. It is one of the oldest homes in El Sobrante and it is still standing. Behind the home is a barn, which is also still standing and serves as a boarding stable for horses. (Courtesy of CCCHS.)

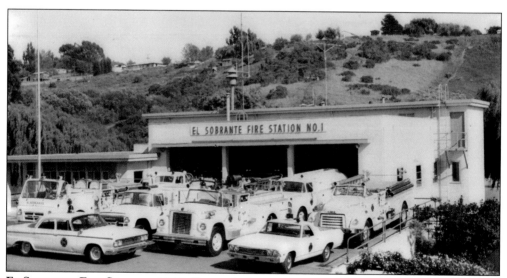

EL SOBRANTE FIRE STATION, 1968. To match the growing community, the fire department had kept up with the demand for adequate equipment. Surprisingly, as of this date, most of the men were still volunteers. As of 1962, only six men were paid out of a staff of 40. That number was only increased to nine in 1969. Note the prominent air horn on the station that was blown in case of a fire. (Courtesy of Harold Huffman.)

Six

THE HILLS ARE ALIVE
1970 TO 2000

"If you sit still, you will be gobbled up by both Richmond and Pinole. This may be your last chance to say where you want to go." These were the words of county supervisor Al Dias, speaking to El Sobrante's chamber of commerce in June 1970. In two months, the City of Pinole chipped away 28 acres, which was later developed into a commercial shopping area along Interstate 80. In the years to come, more acreage would be annexed to the City of Richmond. However, the window of opportunity for incorporation had passed—too much land had already been lost. For a time, the idea of creating a contract city, an arrangement allowing for tax collection and contracting for services with the county, was considered; however, this idea also failed to generate sufficient support. The sky did not fall; in fact, residents hardly seemed to notice the change. Life went on.

In 1973 the San Pablo Reservoir was opened to the public after decades of agitation and political maneuvering. Opening day was something of a madhouse, with a mile-long traffic jam and frayed tempers. With the opening, El Sobrante, already associated with the dam, acquired a new status in the Bay Area.

In the 1980s, housing projects began to move further up the hillsides, long known for their instability. Their increased visibility and concerns for downhill damage to existing homes led to increased resistance to development. By the 1990s, and as El Sobrante moved into the 21st century, development had slowed, often for reasons other than local resistance. It was time for the community to reexamine itself and to look to its future.

CHECKING NEW COMMUNICATION EQUIPMENT, 1971. The El Sobrante Fire Department continued to keep up with technological changes and was often the first in the area to adopt new ideas and techniques. The man pictured is Howard Huffman, who was assistant chief and acted as interim chief for about two years after Chief Matteson died early in 1969. (Courtesy of CCCFPD, Station 69.)

BETTY DEGRACE, FITZGERALD DRIVE AREA, 1971. Betty is riding Serena, while the little horse is Serena's daughter Glory. This photograph was taken in what is now the Fitzgerald Drive area, about where the Orchard Supply Hardware Store now stands. The building in the background to the right is Juan Crespi Jr. High School. (Courtesy of Betty DeGrace.)

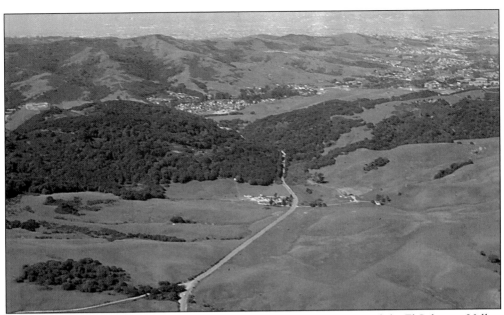

AERIAL, CASTRO RANCH ROAD, 1973. This photograph looks west toward the El Sobrante Valley. The area in the foreground along both sides of Castro Ranch Road became heavily developed. On the left side of the road just up from the tree line is the old O'Neill Ranch. On the right is the Cutter Lab facility. The road branching off from the main road at the top of the hill leads to the Nunes Ranch. (Courtesy of John Koepke.)

CARRIAGE HILLS NORTH AREA, PREDEVELOPMENT, 1977. Before being developed, the land was owned by Cutter Laboratories. The company raised cattle and horses and produced tetanus and diphtheria vaccines using the animals' blood. When the new development was built in the 1980s, the developer donated the ridge land to the EBRPD, creating the Sobrante Ridge Regional Preserve. (Courtesy of Betty DeGrace.)

DAM CYCLES, 1970s. For well over 30 years, Dam Cycles has operated at this location at 4036 San Pablo Dam Road. Several of these unidentified boys are astride Indian dirt bikes, which enjoyed a brief popularity in the early 1970s. The cycle shop went out of business around 2008. (Courtesy of Lyle Miller.)

DOWNTOWN EL SOBRANTE, JUNE 1973. In January of this year, a skating rink called the Roll-O-Torium opened at 3645 SP Dam Road. Roller-skating was very popular at the time and it was hoped that competitive teams would develop. The facility has closed and is now the home of Thrift Town. The LoRay store has also closed and is now a Salvation Army thrift store. (Courtesy of John Koepke.)

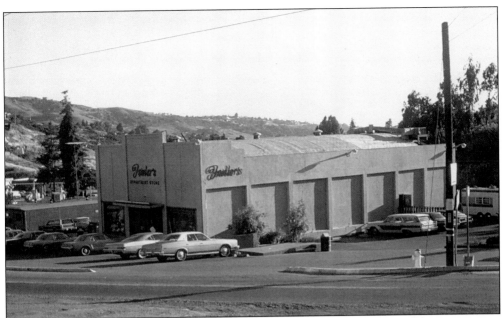

FOWLER'S DEPARTMENT STORE, JUNE 1973. Logan Fowler began his clothing business on San Pablo Dam Road in 1958. In 1965, he moved to this building at the "Y" along Appian Way, previously Vogel's Market. This area has been, in many ways, the second business area of El Sobrante, with many shops and stores. The building is still standing today. (Courtesy of John Koepke.)

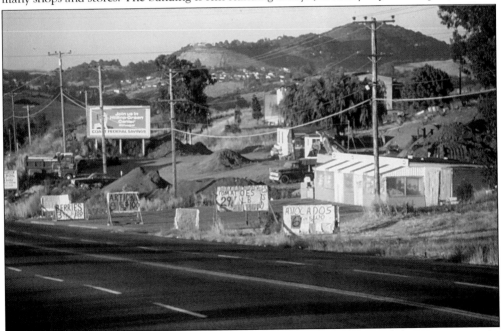

VEGETABLE AND FRUIT STAND, SAN PABLO DAM ROAD, JUNE 1973. This photograph looks east, down the slope from the top of what was once called, in our less politically correct days, "Chinaman's Hill." The area was apparently named after a Chinese landowner who farmed the area. In September 1973, the land was annexed to the City of San Pablo. The site is now home to many food-related businesses. (Courtesy of John Koepke.)

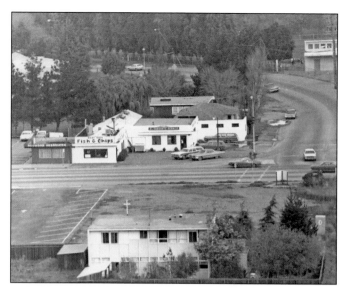

SAN PABLO DAM ROAD AND EL PORTAL, c. 1970. Moby Dick Fish & Chips opened late in 1969 and was owned, appropriately enough, by two English families. Next-door is the *El Sobrante Herald* office. Since 1947, Ed Galli had published the *Herald*, a weekly newspaper that strictly ignored anything but local news; he did not even cover President Kennedy's assassination in 1963. The paper was sold to West Contra Costa Newspapers, Inc., in 1972. (Courtesy of Ed Rossman.)

PARK DEDICATION, SAN PABLO RESERVOIR, JULY 19, 1973. As early as 1936, sportsmen were agitating to open the San Pablo reservoir to fishing, but due to the potential threat of contamination, EBMUD consistently opposed such a move. In 1959, Gov. Edmund Brown signed a law permitting recreational use of all reservoirs, except for swimming. Another 14 years passed before the dream would become a reality. (Courtesy of EBMUD.)

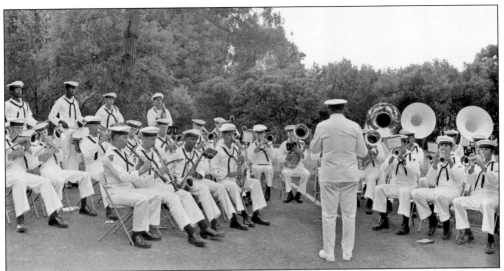

US Coast Guard Band, SP Reservoir Park Dedication, July 19, 1973. The opening of the EBMUD reservoir to recreational fishing and boating was an extremely important event, not just for recreational users, but also for the community of El Sobrante. From the beginning, the facility has been linked to El Sobrante with the hearty support of EBMUD, and is generally seen as an amenity of the El Sobrante area. (Courtesy of EBMUD.)

Clarence Wilson Honored, July 19, 1973. At the dedication ceremony, Clarence Wilson was presented with this plaque in recognition of his "40 years of untiring effort on behalf of California sportsmen, and his dedicated leadership which helped make possible the opening of East Bay Municipal Utility District Reservoirs for public recreation." (Courtesy of EBMUD.)

OPENING DAY, SAN PABLO RESERVOIR, JULY 23, 1973. The actual opening of the reservoir was a few days following the dedication. The 700 space parking lot was filled by 8:30 a.m. and subsequent arrivals had to park along San Pablo Dam Road. All the boats were rented by 9:00 a.m. Shoreline anglers still were successful, as seen by this stringer of trout. (Courtesy of EBMUD.)

MORE HAPPY FISHERMEN, JULY 23, 1973. The primary attraction at the reservoir was expected to be, and always has been, fishing. Some species of fish were naturally present in the lake, including black bass, bluegill, and crappie. At the time of the opening, some species had been planted, primarily trout and catfish. (Courtesy of EBMUD.)

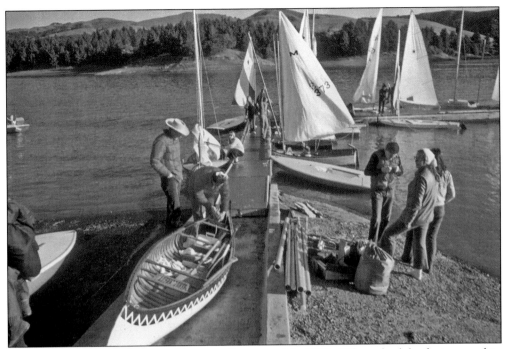

OPENING OF BOAT LAUNCHING FACILITY, JANUARY 26, 1974. When the lake first opened in August 1973, the boat launching ramp was not yet completed and the facility was restricted to sailboats and canoes up to 25 feet in length. About 120 boats showed up for the first day. (Courtesy of EBMUD.)

CANYON PARK MARKET, 1973. This little market, located at 3931 Clark Road, served the community of El Sobrante since the Canyon Park housing was constructed in the late 1940s. By 1973, it was closed and boarded up. The little structure had had a long and varied life, originally serving as the Sheldon School, a bunkhouse, and a store. (Courtesy of Contra Costa County Library.)

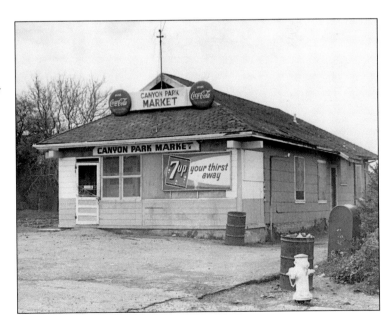

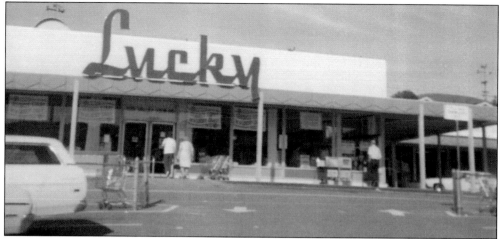

LUCKY STORE, WHITECLIFF SHOPPING CENTER, 1973. Lucky opened their store at the corner of Valley View and May Roads in August 1961. The rapid growth of the area, beginning in the mid-1950s, indicated that a store and shopping center were needed nearby. The store later became a part of the Albertson chain. It has since been torn down to make way for more homes. (Courtesy of the Contra Costa County Library.)

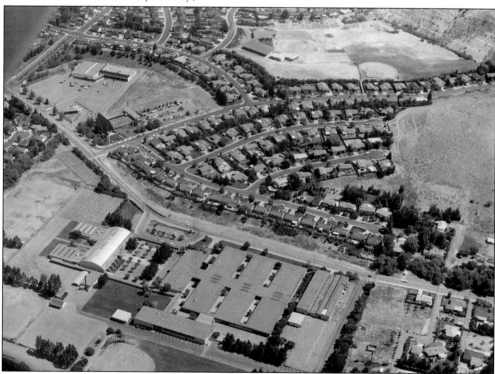

EL SOBRANTE AERIAL, 1973. De Anza High School occupies the lower portion of this photograph, with the gym to the left and the baseball field at the bottom. In the upper left of the photograph is the Whitecliff, or Valley View, shopping center between May Road and Morningside Drive. Just at the corner of Valley View Road and Morningside Drive is the Trinity Lutheran Church, which was dedicated in 1961. Farther up Morningside Drive to the left is Valley View Elementary School. (Courtesy of Contra Costa County Library.)

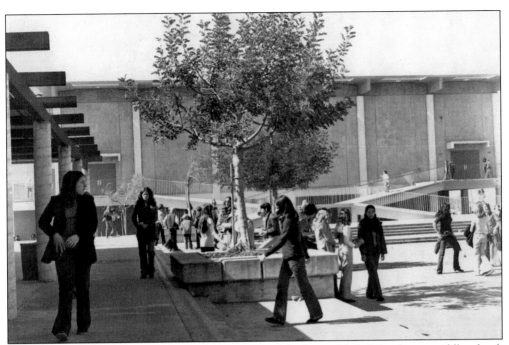

JUAN CRESPI JR. HIGH SCHOOL, 1973. Construction of this Junior High School, now middle school, located on Allview Avenue, began in 1964 and was completed in 1966, under the architectural direction of Hardison and Komatsu of Richmond. (Courtesy of Contra Costa County Library.)

ED GALLI, OCTOBER 1973. Publisher of the only newspaper that El Sobrante ever had, Ed Galli was a very influential person during the formative years of the community. An old newspaper man, he tirelessly advocated for improvements to the local infrastructure and railed against attempts, particularly by Richmond, to annex parcels of land. Behind him is county supervisor Al Dias, who is sticking out his tongue. (Courtesy of John Koepke.)

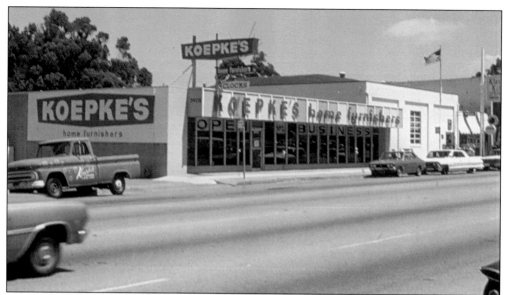

KOEPKE'S, MAY 1974. John Koepke and his father, Horace, opened this shop together after running separate businesses in and around El Sobrante for years. The building next to it that is flying the American flag is the post office, which opened in early 1957. Beyond the post office is the Klassic Kitten, a bar that featured seminude dancers in a space that originally was Lee's Variety Store. The Klassic Kitten closed in 1975, after losing its liquor license and incurring the wrath of 28 local churches. It is now home to the Elks Club. (Courtesy of John Koepke.)

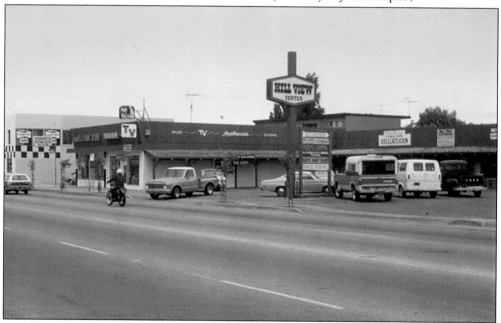

HILL VIEW CENTER, JUNE 1975. This little shopping center originally opened in July 1960. The grand opening was widely advertised, and prizes, including an all-expense paid vacation for two to Las Vegas, were given out to lucky attendees. The businesses have changed over the years, but otherwise this part of the business section of El Sobrante looks much like the same as it did when first built. (Courtesy of John Koepke.)

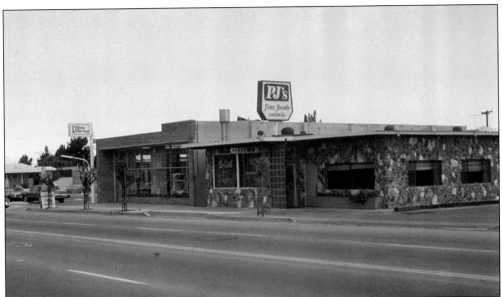

PJ's and State Savings, June 1975. The building housing the current restaurant and bar is another one of those structures that have had a long life along El Sobrante's business corridor. The State Savings office originally opened in September 1973, on the opposite side of San Pablo Dam Road. They quickly outgrew that location and moved across the street when this building became available in July 1974. (Courtesy of John Koepke.)

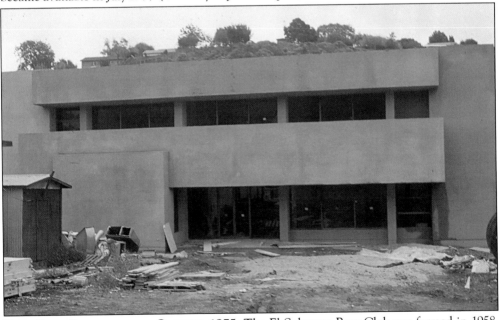

Boys Club Construction, October 1975. The El Sobrante Boys Club was formed in 1958, and for years activities were held in a small building located on the current site along Appian Way. In early 1962, the first full-time director, Charles Wells, assumed his duties and immediately began planning for a much larger structure. The building was finally opened in 1978. The Boys Club merged with the local Girls Club in 1998, and the present Boys and Girls Club was born. (Courtesy of John Koepke.)

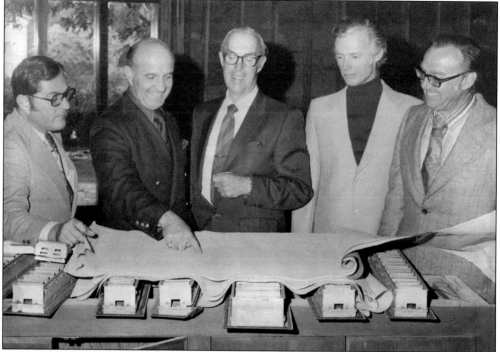

LIBRARY EXPANSION PROJECT CEREMONY, JULY 8, 1974. In the mid-1970s, the library was nearly tripled in area, and a multipurpose room was added. An unexpected summer rainstorm forced the dedicatory event indoors. Pictured from left to right are Clarence Walters (county librarian), Alfred Dias (supervisor), A.B. Miner (president of Friends of the El Sobrante Library), John Wilson (project architect), and Robert Sharp (El Sobrante Chamber of Commerce). (Courtesy of Contra Costa County Library.)

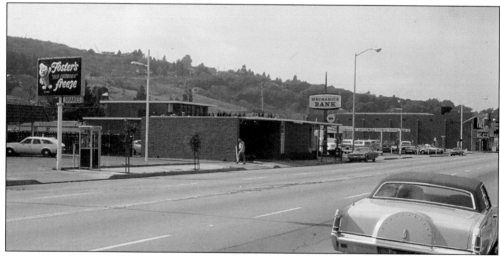

MECHANICS BANK, 3826 SAN PABLO DAM ROAD, FEBRUARY 1976. This bank originally opened in May 1955. Bank president E.M. Downer said that the branch was opened "to meet the banking needs of people in this rapidly growing area." The bank came with a drive-in window, which was seen as a notable convenience. The building is now home to the Pedaler Bike Shop. (Courtesy of John Koepke.)

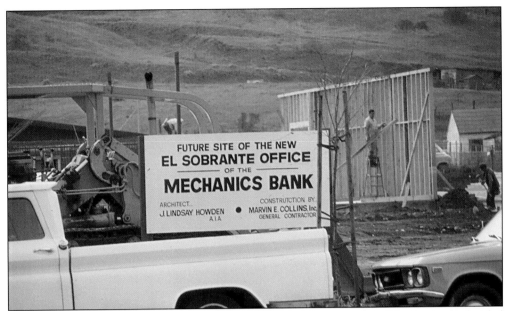

BUILDING THE NEW MECHANICS BANK, FEBRUARY 1976. After more than 20 years, it was decided to replace the existing bank with a larger building and construction began early in 1976. The site is just to the west of Rancho Liquors. The bank is still very much in business, though without a drive-in window. (Courtesy of John Koepke.)

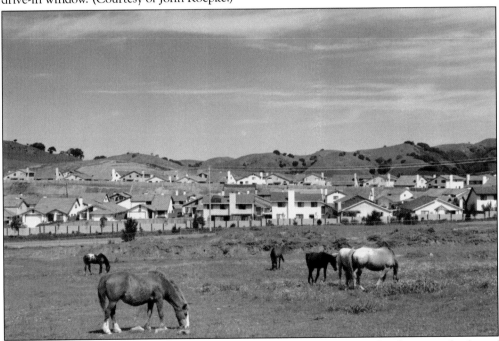

CONSTRUCTION OF CARRIAGE HILLS NORTH DEVELOPMENT, 1986. This development, the first of two that were built along Castro Ranch Road, generated much controversy among local residents who viewed the large project as destructive of El Sobrante's rural character. In addition, the almost routine annexation of land for such projects by the City of Richmond led to negative feelings regarding that city's intentions, which persist to this day. (Courtesy of Betty DeGrace.)

117

EL SOBRANTE ACTIVISTS, 1989. Pictured are Eleanor Loynd (left), Bob Sullivan (center), and Rosemary Corbin. Both Eleanor and Bob had long been active in El Sobrante politics. On this occasion, they were meeting with the newly elected mayor of Richmond, Rosemary Corbin. They are standing along Heavenly Ridge Drive, and the view is southwest. (Courtesy of the Loynd family.)

ELKS CLUB, 1999. Originally constructed as a variety store by Claude Lee in 1957, this building also served as the home of the Klassic Kitten until 1975. For a few years after that, it continued to operate as a bar, offering country and western music. In 1978, Richmond Elks Lodge No. 1251 moved in and began construction of a substantial addition in 1985. The lodge is still active and has integrated itself into the fabric of El Sobrante community life. (Courtesy of Richmond Lodge No. 1251.)

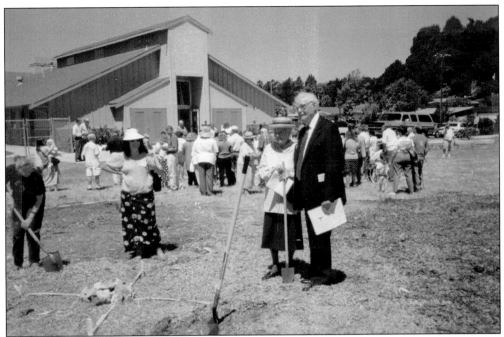

GROUND BREAKING, HOPE LUTHERAN CHURCH, JUNE 1999. With the closing of St. Timothy Lutheran Church in El Sobrante and Gloria Dei in Pinole, the congregations merged. They began to build their new facility on May Road in the early 1990s, and two buildings were constructed. Since the general consensus was that the children's needs should be met at once, they first built a parish hall and a preschool—this is the building visible in the above photograph. This building also served as the church until the new building was completed. In the photograph below, the new church can be seen under construction in 2000. Hope Lutheran is one of the more active churches in El Sobrante and often serves as a meeting place for events of general community concern. (Above, courtesy of Hope Lutheran Church; below, courtesy of Evelyn Botti.)

CAPRI CLUB AND WADSWORTH GLASS CO., APPIAN WAY, MARCH 2000. Along with Clancy's, the Rancho, and Ed's Place, the Capri Club is a classic American bar—blue collar, unpretentious, and a little edgy. The current owner, Don Peterson, is a Harley-Davidson motorcycle enthusiast, and the place has acquired the reputation of being something of a biker bar. Wadsworth Glass opened here in 1963 and has moved to the old post office building on San Pablo Dam Road. (Courtesy of Don Peterson.)

EARTH DAY, 2000. Thirty years after the original Earth Day in 1970, the San Pablo Watershed Neighbors Education and Restoration Society (SPAWNERS) was born. One of its first projects was to clear away the invasive ivy that grew on county land behind the library and down to San Pablo Creek. Part of the group's mission is to involve the community in the creek's restoration, especially the younger members. The group is still going strong. (Courtesy of SPAWNERS.)

Epilogue

YESTERDAY AND TODAY

As the community of El Sobrante moves into the 21st century, it is clear that much has changed. Businesses have come and gone. Some buildings are empty and tenants, as in many communities, are hard to find. Growth has stalled, however. For many, this is a good thing.

Perhaps the most dramatic change to take place in the last few decades is in the area of diversity. For much of its history, El Sobrante has been predominantly white. Even as late as 1960, the white population was estimated to be 99 percent. By the beginning of the new century, that figure had dropped to 60 percent, offset by sizeable and growing populations of African Americans, Asians, and Latinos. It is also the home of a large and growing Sikh population, whose golden-domed Gurdwara Sahib sits prominently in the hills along Hillcrest Road.

The varied color of the emerging community is wonderfully displayed at the annual El Sobrante Stroll, which takes place on the third Saturday in September. The main street is closed to automobile traffic, allowing for a parade, music, and general merrymaking. Since 1994, this unique event has acted as a kind of community family reunion, where residents reestablish old acquaintances or make new ones. It has grown larger each year and has become an event that is a year in the planning. An active participant in the stroll is the SPAWNERS group, which has taken on the task of reacquainting the community with its oldest asset and amenity—San Pablo Creek. Since 2000, this small group of dedicated volunteers has become a voice for the creek, which whether acknowledged or not, is the tie that has always bound the community together.

Though El Sobrante will likely never be incorporated, it still remains a viable community with a powerful sense of itself and its uniqueness. It is, and always has been, a community of individuals.

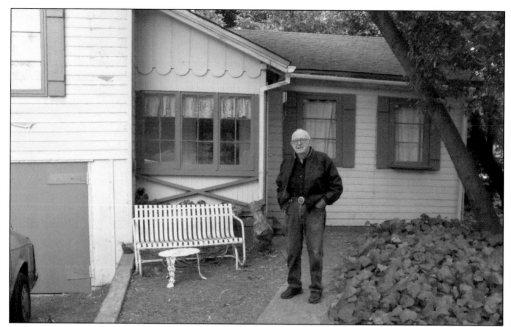

Edward Campbell, 1 Campbell Lane, 2010. Ed Campbell grew up in El Sobrante, and has been a principal source of information for this book. He is standing by the home that his father built in 1934. The home has changed little over the years. Compare this image with the one at the bottom of page 35. (Author's collection.)

Richmond High School Military Class Site, 2011. Flip to the photograph at the bottom of page 31 and compare it with this recent photograph, taken above the Canyon Oaks housing development located on San Pablo Dam Road, a little east of the intersection with Castro Ranch Road. While much has changed, this is the spot where Richmond High senior boys spent their five-day encampments in the years following World War I. (Author's collection.)

PEDRACCI FAMILY HOME, 2010. Kurt Pedracci and Cindy Lane purchased the old Maloney home in the 1990s, and have been fixing it up ever since. The main building, not pictured, has been extensively remodeled, but retains the bones of the original. The little shed at the left of this photograph is quite old and appears in the photograph at the top of page 30. Kurt built the building to the right, replacing the old barn. (Author's collection.)

OLD CASTRO ROAD, CASTRO RANCH, 2009. This road is actually a portion of the old Castro Road, which at one time, curved through what was the old Percy Castro home, now Naphan Ranch. The current Castro Ranch Road now bypasses this little loop, but it can still be seen where it approaches the highest point of the road. (Author's collection.)

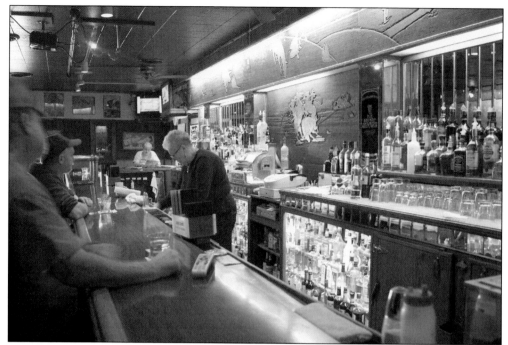

INSIDE THE RANCHO TAVERN, 2011. The bartender is Margaret Faria Prather, and the bar is now owned by John Oliver. Opened in August 1950 as Tom's Tavern and Delicatessen, the local newspaper claimed that it was "reeking with Wild West atmosphere." That atmosphere is still evident in this photograph. While each of the major bars in El Sobrante, including Ed's, Rancho, Clancy's, and the Capri Club have their own patronage, all have managed to retain the unique essence of the classic American bar of the 1950s and 1960s. (Author's collection.)

THODE RANCH HOUSE, 2011. Built in the 1880s, this is one of the oldest structures in El Sobrante and is still very much in use. Compare this photograph with the one on the top of page 102. The windows have been updated, but otherwise the house is little changed. Behind the house is the barn that has served as a horse stable for decades. (Author's collection.)

CCC Rock Wall, San Pablo Dam, 2011. If this photograph is compared to the photograph at the bottom of page 41, the rock wall can be seen. The CCC built the rock wall in 1935. Though partially covered with soil, the right end of the wall can be seen projecting from behind the toilet facility. Just to the right of the cyclone fence at the left, one can make out the pillar at the middle of the wall, which leads to stone steps on the other side. The outfall tower can be seen just between the two large trees. The bottom photograph shows the steps leading down from the middle of the wall, almost to the water's edge. From this angle, the steps look almost like the ruins of a Mayan temple. This is a charming historical site, one worthy of a modest interpretive exhibit. (Author's collection.)

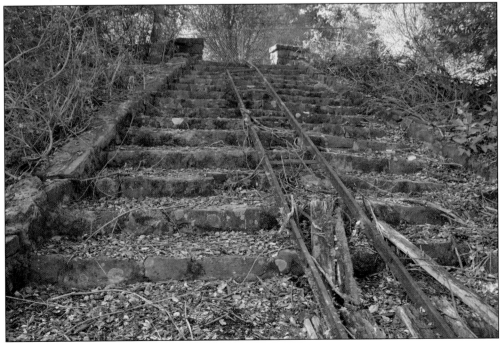

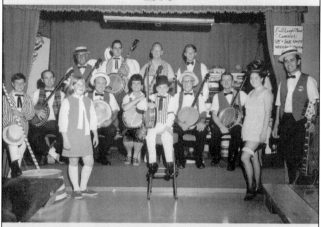

EL SOBRANTE BANJO BAND
1970

Back Row L to R: Lyle Plummer (Scotty's brother), Phil Anderson,
Alvin Ekenberg, Maury Postle, Fritz Marg, Danny Morgan & John Horton (far right)
Front Row L to R: Linda Morgan, Herbie Uth, Sally Burns, Scotty Plummer,
Kenny Smith, Bobbie Morgan & Betty Jo Price.

EL SOBRANTE BANJO BAND, SOBRANTE PIZZA PARLOR, 1970. The music scene has long been active in El Sobrante. Live music is still very much a part of the community life of El Sobrante. Kirk Hammett of Metallica and Exodus grew up in El Sobrante and graduated from De Anza High School in 1979; Les Claypool of Primus grew up in El Sobrante and graduated from De Anza in 1981. One Primus song is called "De Anza Jig." John Kiffmeyer (Isocracy, Green Day) is also an El Sobrante boy, his nickname being "Al Sobrante." (Courtesy of Ed Rossman.)

INSIDE SIKH TEMPLE, AUGUST 7, 2010. The Gudwara Sahib in El Sobrante is open to the public, and food and tea are usually available to the visitors. The colorful temple along Hillcrest Road opened its doors in 1993. Everyone seems to join in the food preparation and serving. In this image, colorfully dressed women prepare bread. (Author's collection.)

PLANTING SUBCOMMITTEE, CHILDREN'S READING GARDEN, 2007. This is the only park in the unincorporated area of El Sobrante. Situated just to the west of the library, it opened in 2007 thanks to funding derived mainly from developers' fees. Much of the planning and work were done by volunteers. Here, SPAWNERS members can be seen laying out the planting plan. Pictured are Elizabeth O'Shea (left), Martha Berthelsen (center), and Judy Ward. (Author's collection.)

EL SOBRANTE STROLL, SEPTEMBER 19, 2010. From an uneven beginning in 1994, the annual Stroll has gradually become a fixture and defining event in the life of the El Sobrante community. Held on the third Sunday in September, it is an event of color, music, dancing, food, and good cheer. Early in the morning, San Pablo Dam Road between El Portal Drive and Appian Way is closed to automobile traffic, which always catches some locals and many others by surprise. (Author's collection.)

DISCOVER THOUSANDS OF LOCAL HISTORY BOOKS
FEATURING MILLIONS OF VINTAGE IMAGES

Arcadia Publishing, the leading local history publisher in the United States, is committed to making history accessible and meaningful through publishing books that celebrate and preserve the heritage of America's people and places.

Find more books like this at
www.arcadiapublishing.com

Search for your hometown history, your old stomping grounds, and even your favorite sports team.

Consistent with our mission to preserve history on a local level, this book was printed in South Carolina on American-made paper and manufactured entirely in the United States. Products carrying the accredited Forest Stewardship Council (FSC) label are printed on 100 percent FSC-certified paper.

MADE IN THE